IMAGES
of America

MILFORD

MILFORD

HILLSBOROUGH CO.
N.H.

1901

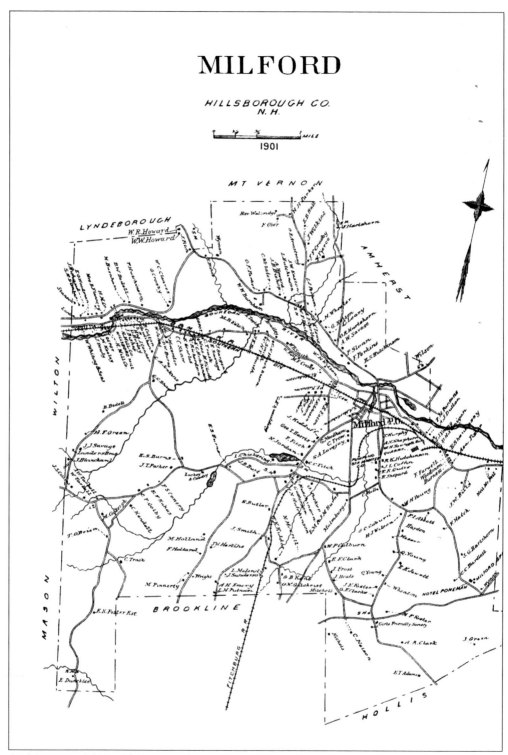

A MILFORD MAP. This map dates from 1901, when the population of Milford was around 3,800.

IMAGES
of America

MILFORD

Christopher J. Thompson

ARCADIA
PUBLISHING

Published by Arcadia Publishing
Charleston, South Carolina

Printed in the United States of America

Library of Congress Catalog Card Number: 2002109041

For all general information contact Arcadia Publishing at:
Telephone 843-853-2070
Fax 843-853-0044
E-mail sales@arcadiapublishing.com
For customer service and orders:
Toll-Free 1-888-313-2665

Visit us on the Internet at www.arcadiapublishing.com

Dedicated with love to my girls, Taylor and Julia.

CONTENTS

ACKNOWLEDGMENTS

Unfortunately, the two people responsible for most of the information contained in this book are no longer with us. George A. Ramsdell was responsible for *History of Milford, N.H. 1738–1901*. Winifred A. Wright brought us *The Granite Town: Milford, New Hampshire 1901/1978*. My appreciation also goes out to the committees and individuals who helped these two authors complete their books. This book would not have been possible without the efforts of so many other people in the past.

I would like to acknowledge every member of the Milford Historical Society from the past and present. It is through the work of the society's members that so much of Milford's history remains with us into the 21st century. I encourage everyone to visit the society on the World Wide Web at www.milfordhistory.com or to visit in person at the Carey House, the society's home, at 6 Union Street in Milford.

Polly Cote and Louie Carey—president and curator of the historical society, respectively—have been able to identify and place pictures that I was not able to. Charles Guidmore, a 30-year employee of the French & Heald Company, helped with pictures and stories. D. James Philbrick of Milford donated several pictures as well as information. Marion Blanchard Kopp of Milford also shared her collection of pictures. Thanks go to Janet Craig for the picture of her grandfather. Mention must be made of Hendrix Wire & Cable and of Arthur Bryan and the Milford Library. Thanks also go the Cabinet Press for preserving so much of Milford's history in its newspapers for the past 200 years. Several of the pictures in the book are from the lifelong collection of the late Bernice Perry of Milford. Thanks to her family, her photography collection is now part of the Milford Historical Society's collection.

On a personal note, I would like to thank all of my friends and family for their love and support. Special thanks go to my parents, John and Orma Thompson, and to Barry and Mary Lou Crawford. My goal in life is to raise my children with the same love and support that they have shown me. I would also like to thank my wife, Pam, for her continued love and support and her tolerance of my always busy schedule between work and hobbies.

INTRODUCTION

Like so many other towns in southern New Hampshire, the area that is now Milford was once part of the Massachusetts Bay Colony. In the mid-1600s, the colony rewarded distinguished citizens and their descendants with tracts of land in the Merrimack, Souhegan, and Nashua River valleys. Most of these citizens gained their high esteem by serving in the military or being active in civil affairs. In 1659, one such tract of land was granted to the schools of Charlestown, Massachusetts, to be used for their benefit. The piece of land became known as the Charlestown School Farm and existed with that name until Benjamin Hopkins of Billerica purchased it in 1743. This school farm was on the south side of the Souhegan River, with its west edge in the vicinity of today's Market Basket and its east edge in the vicinity of today's Granite Town Plaza. Other tracts were granted to individuals as well. These grants were mostly to the east and to the south of the Charlestown School Farm. Not long after these grants were established, settlements started appearing in the area that is now Nashua. The early settlers of these grants felt the need to organize and establish a township.

The settlers petitioned the General Court and, in 1673, the old township of Dunstable was chartered. Dunstable consisted of parts of present-day towns in New Hampshire—Nashua, Hollis, Amherst, Merrimack, Milford, Brookline, Litchfield, Hudson, Londonderry, and Pelham. It also included parts of the current towns of Tyngsborough, Dunstable, Pepperell, and Townsend in Massachusetts. In today's Milford, only the land south of the Souhegan River and east of an ungranted tract of land called the Mile Slip was part of the old township of Dunstable. Dunstable also included the Charlestown School Farm.

Other areas of today's Milford include another grant, called Narragansett No. 3, or Souhegan West. This grant was laid out in 1733 and included today's northeast section of Milford. This area today includes the transfer station, Amherst Street, and Souhegan Street. In 1760, this grant became a part of Amherst. The Duxbury School Farm was also granted in 1733 for the benefit of the schools of Duxbury, Massachusetts. This was a 500-acre tract of land on the north side of the Souhegan River just to the west of Narragansett No. 3. This tract of land includes today's North River Road to the east of Fitch's Corner. The Mile Slip was a tract of land that was just over a mile wide and stretched from the Massachusetts border (established in 1741) to the Lyndeborough border. To the west, it bordered Mason and Wilton and, to the east, Dunstable and Duxbury School Farm. This strip of land was never granted by Massachusetts and fell under its own jurisdiction.

In 1741, the state line between Massachusetts and New Hampshire was established. After the state line was established, the old township of Dunstable was eventually broken up into several

parts. One of those parts became the short-lived town of Monson in 1746. Monson consisted of the entire portion of Milford that had been the old township of Dunstable, plus sections of the current towns of Hollis, Amherst, and Brookline. Monson consisted of 20,000 acres, and the center of this town was located in Milford very near the Hollis town line off Federal Hill Road. The land that is Milford's current Union Square was at the northern edge of Monson's town line. Fifteen families lived in Monson when it was incorporated in 1746. The list of taxpayers in 1753 listed 33 men. By 1770, the list of taxpayers had grown to include 76 men. It was in 1770 that the town of Monson petitioned the state of New Hampshire to end its corporate existence. According to history, the residents were not able to build a meetinghouse due to the location of the center of town. With most residents living on the outskirts (what we now think of as downtown Milford), it did not make sense to build a meetinghouse that far away. The north end of Monson became part of Amherst, and the southern half of Monson went to Hollis. From 1770 until Milford was incorporated in 1794, the land that is now Milford (with the exception of the Mile Slip and the Duxbury School Farm) was a part of Amherst.

In 1794, the state approved the petition to combine the areas then known as Amherst (the majority of the land), the Mile Slip, the Duxbury School Farm, and a small portion of Hollis into what is now known as Milford.

The name Milford was derived from a ford at the mill. As early as 1741, one of the early prominent citizens of the area, John Shepherd, was hired by the citizens of Souhegan West to build a gristmill and sawmill on the north side of the river just to the east of the current stone bridge coming out of Union Square. John Shepherd received 120 acres of land in exchange for the building and operation of the mill. It was also in this vicinity that there was a ford (a shallow spot) in the river where people crossed the river in the days before modern bridges. This area became known as the Mill-Ford Village.

One

BUSINESS AND INDUSTRY

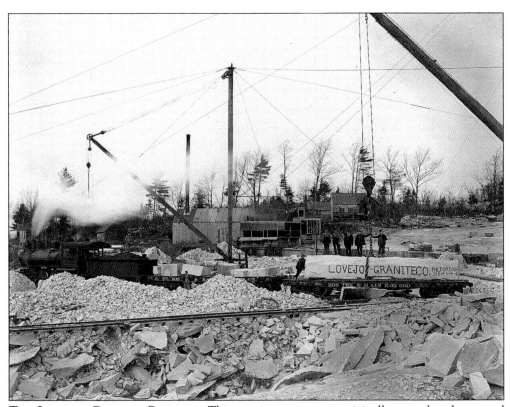

THE LOVEJOY GRANITE COMPANY. This granite quarry was originally owned and operated by Nathan Merrill. It was in the hands of Samuel Lovejoy by 1894. Lovejoy owned it until 1923, when H.E. Fletcher of Chelmsford, Massachusetts, became the sole owner. This quarry is located on the large tract of land circled by Melendy Road, Armory Road, and Route 13.

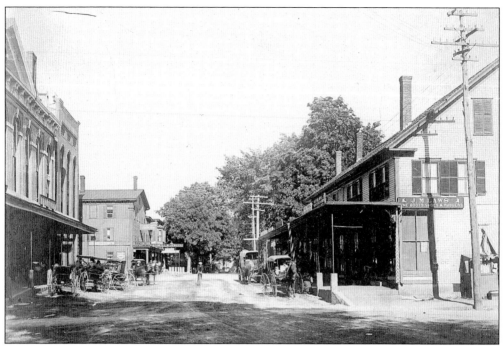

J.M. LAWS SHOES. The store space at the corner of South and Nashua Streets has housed a shoe store for more than 100 years. When this photograph was taken, James Laws was the business owner. Laws was also the Western Union Telegraph operator in town from 1889 to 1906.

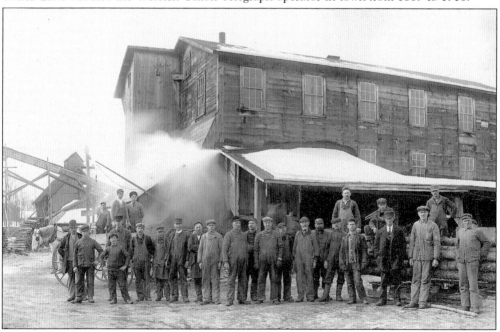

THE WHITE MOUNTAIN FREEZER COMPANY. This Nashua company was formed in 1879. The employees in Milford are pictured in this undated photograph. The building appears to have been located near the depot on Cottage Street. The White Mountain Freezer Company also had a facility near Jones's Crossing. After 84 years of business, the company shut down in 1963.

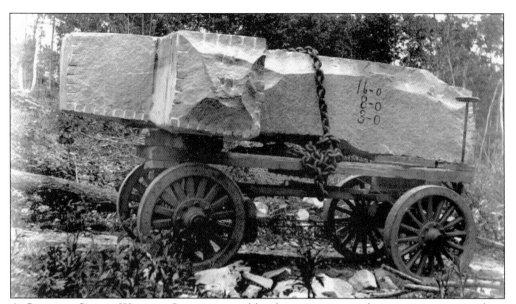

A GRANITE STONE WAGON. Stone wagons like this one were used to transport granite from the quarries to the stone sheds for cutting and to the train stations for shipment. A few of the quarries were lucky enough to have rail lines run directly to their quarries. Milford's own blacksmiths and wheelwrights were the makers of these wagons.

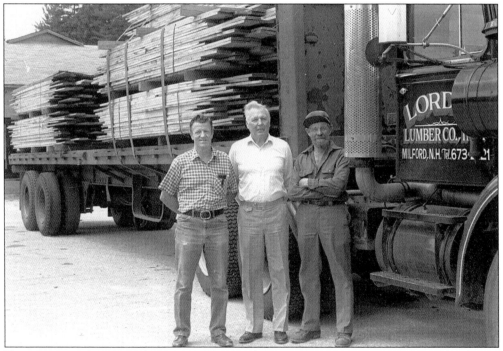

THE LORDEN LUMBER COMPANY. The Lorden Lumber Company was once the largest wholesale lumber company in all of New England. The company was located where today's Lorden Plaza is in East Milford, as well as across the street. This photograph shows the last load of lumber being delivered before the company closed. From left to right are Charles Woods, Kenneth Lorden, and ? Salisbury.

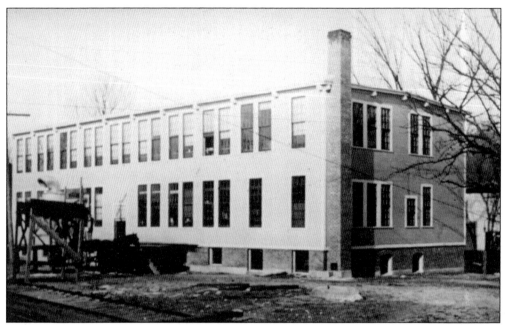

THE QUAKER SHOE COMPANY. This three-story manufacturing plant on Clinton Street was the home of the Quaker Shoe Company. The building was constructed in 1912 with the financial help of the people of Milford. The business ceased to exist after October 1915.

MERRILL'S QUARRY. This view shows the Lovejoy granite quarry off Melendy Road before Samuel Lovejoy owned it. At the time of this picture, Nathan Merrill owned the quarry. Merrill sold his quarry to Lovejoy in 1894. It was from this quarry that the 31 columns of the Treasury building in Washington, D.C., were cut in 1908.

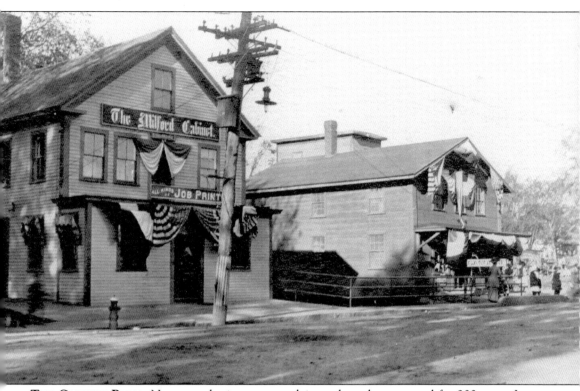

THE CABINET PRESS. Not many businesses can claim to have been around for 200 years. In 2002, the Cabinet Press celebrated its 200th anniversary. The building on the left was its place of business from 1893 until 1950, when the company moved into its present home, the old brick school on School Street. The building has since been heavily remodeled and is on Elm Street across from Union Street. The building on the right was the old Kendall and Wilkins gristmill store building and sat on the property that is now Texaco on Union Square. The building behind the store was the mill building, which was built sometime before 1793. Both were torn down in the 1940s to make room for a service station. This picture may have been taken in 1911 during Milford's industrial carnival.

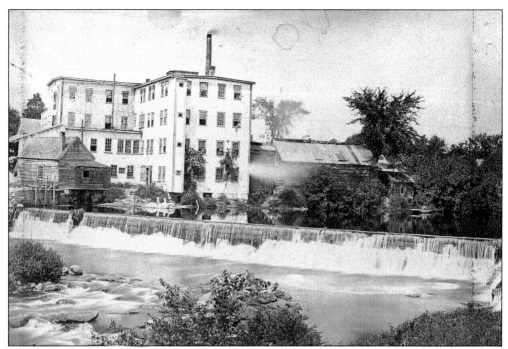

THE FRENCH & HEALD COMPANY. Next to the dam just below the green swing bridge sat the furniture factory of the French & Heald Company. This picture, taken from the Souhegan Street side of the river, shows the factory before a large four-story annex was added to the building (below).

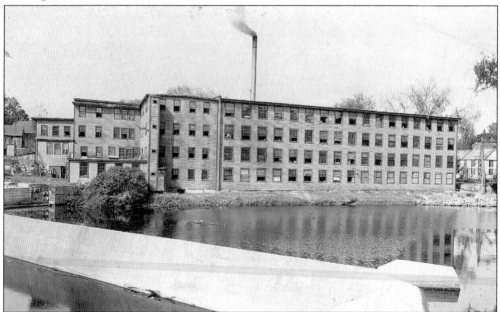

THE FRENCH & HEALD ADDITION. This photograph of the French & Heald factory must have been taken sometime between 1905 and 1912. Taken from about the same vantage point as the above picture, this one shows the four-story annex that was added to the building in 1905. The west end of the swing bridge can be seen at the far end of the new annex.

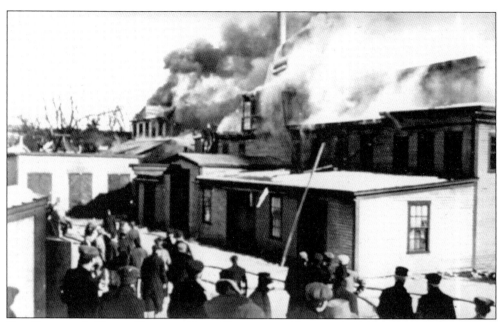

THE FRENCH & HEALD FACTORY FIRE. The events of January 6, 1912, put some 150 Milford residents out of work. On a bitterly cold morning, the entire French & Heald factory was completely destroyed by fire. Today, this location is occupied by the Granite Square building next to the swing bridge.

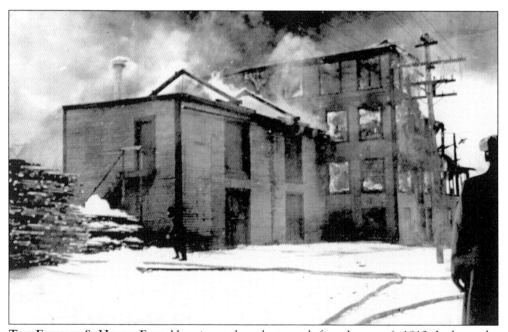

THE FRENCH & HEALD FIRE. Here is another photograph from January 6, 1912. It shows the devastating fire that claimed the entire factory. A new plant was built on the property that is now the Edgewood Plaza. French & Heald was eventually bought out by Sprague & Carleton and remained in business in Milford until 1967.

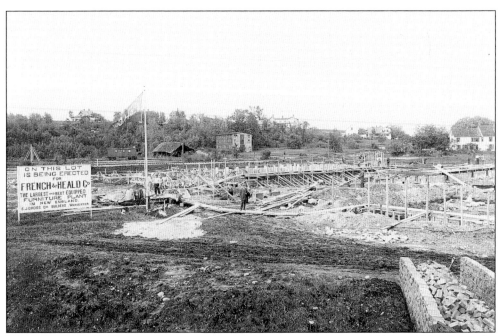

EARLY FRENCH & HEALD CONSTRUCTION. This photograph from 1912 or 1913 shows the very early stages of construction of the new French & Heald plant on Nashua Street after the fire. At this time, there were far fewer trees in Milford, as the houses of Prospect Street can be seen in the background.

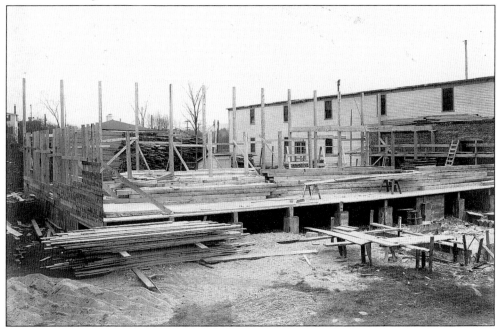

FRENCH & HEALD CONSTRUCTION. A $50,000 bond issue was raised by the people of Milford after the fire that destroyed the French & Heald plant in early 1912. The money was used to help the company rebuild a new plant. At the time of the fire, the factory employed around 150 people from Milford.

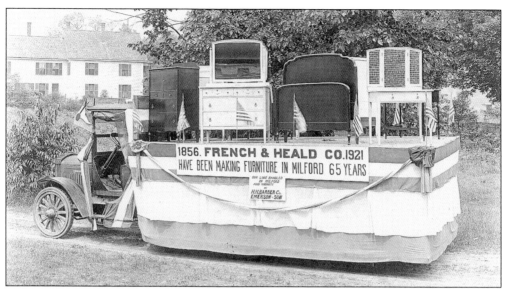

FRENCH & HEALD FURNITURE. This photograph, probably taken in 1921, shows what must have been a float for Milford's Memorial Day or Labor Day parade. The picture appears to have been taken on the west end of the French & Heald property on Nashua Street directly across from the stone house.

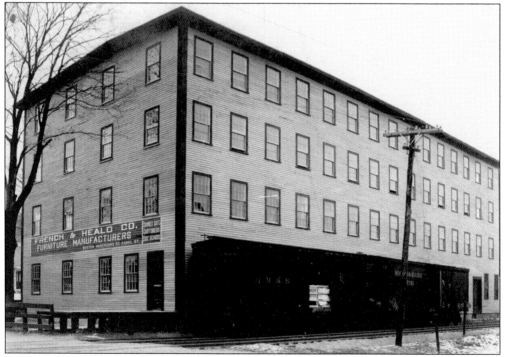

THE CORNER OF SOUTH AND CLINTON STREETS. Prior to 1911, this building was only one story high and was owned by the Francestown Soapstone Company. French & Heald purchased the building in 1911, and the company added the top three stories to the building. Only four years later, French & Heald took this entire building apart and used the lumber and materials for an addition to its main factory on Nashua Street, where the Edgewood Plaza is today.

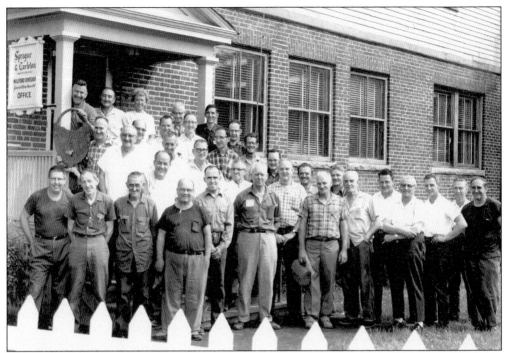

THE FACTORY CLOSING. In May 1967, the workers of Sprague & Carleton gathered for this photograph shortly before the company shut down. Before Sprague & Carleton purchased the business, it was known as French & Heald, which started operations in Milford in 1856.

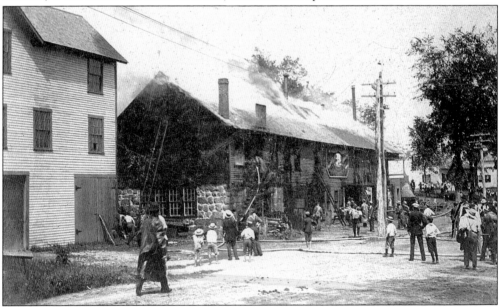

THE OLD BLACKSMITH SHOP. This undated picture appears to show a fire at the old blacksmith building on Elm Street. The original blacksmith shop at this location was built in 1832 by Martin W. Hall and lasted for seven years before it was destroyed by fire as well. Businesses on this site have included Milford's first pound, the blacksmith shops, the Manchester Buick Company, Fletcher Paint Works, and Milford Consignment Outlet.

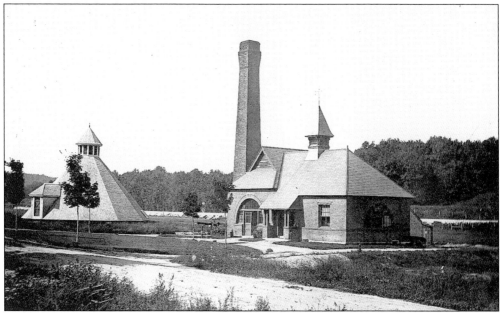

THE PUMPING STATION. The Milford Water Works was a privately owned corporation for the first three years of its existence. The town took over in 1890. The pumping station was built in 1889. By 1907, there were 507 users hooked up to the town water system. Today, this is the location of the public works department.

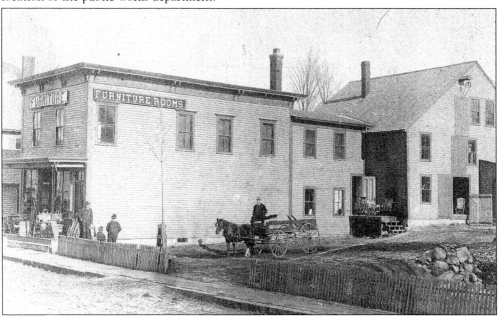

THE EMERSON FURNITURE STORE. Few people would recognize this building as the first building on Union Street across from the community house lawn. The first floor of the building has housed various restaurants over the past 50 years. The building was moved to its current site in 1895 from its previous location on South Street. It was the home of the Emerson & Son's furniture store. The Emersons built the current brick block on South Street after their building was moved.

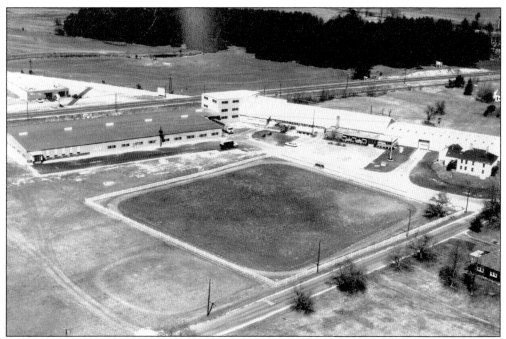

HENDRIX WIRE & CABLE. Hendrix Wire & Cable, pictured in 1967, is one of Milford's largest employers and has been for quite some time. Bill Hendrix started the business in 1951, and the business recently celebrated its 50th anniversary. The company manufactures underground and overhead medium-voltage power cables.

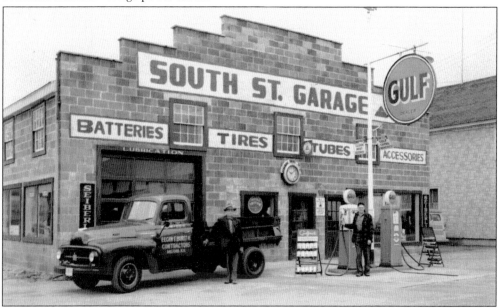

THE SOUTH STREET GARAGE. This business was located on the corner of Lincoln and South Streets. In 1953, Donald Dunklee owned it. Sometime after 1974, this location became Do-All Rent-All. The building now houses an automotive repair shop. The building to the north is no longer standing, and the location now serves as a parking lot. This picture was taken on April 18, 1953.

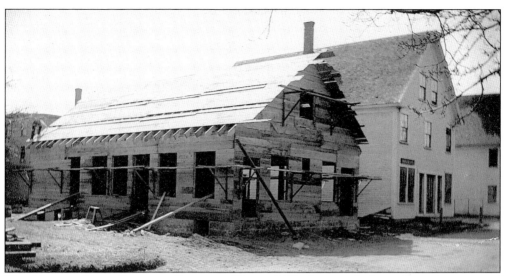

THE MILFORD FARM PRODUCE COMPANY. This c. 1910 photograph shows the construction of what became known as "the Creamery." The business was located at the corner of Garden Street and Union Street where there is now a parking lot. Until this milk-processing plant was opened, Milford farmers had to ship most of their product to Boston via refrigerated (with ice) boxcars.

THE CREAMERY. Shown is another view of the Milford Farm Produce Company on Garden Street. This building was at this location for 47 years before being torn down in 1957 to make room for a parking lot for the Draper Chevrolet dealership next door. Today, this spot is still a parking lot for Granite Industrial Trucks, which occupies the building that once housed the automotive dealership.

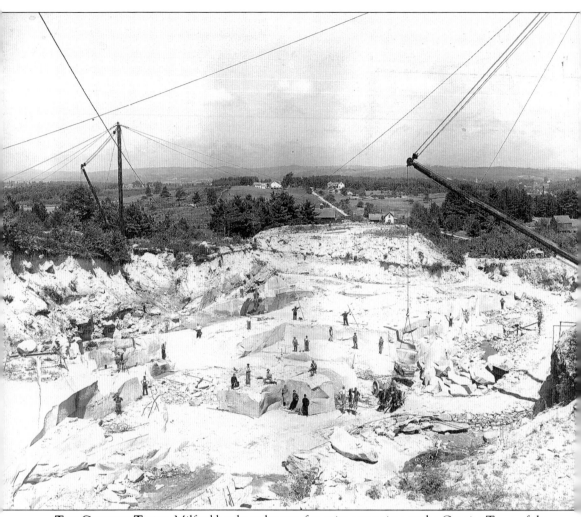

THE GRANITE TOWN. Milford has been known for quite some time as the Granite Town of the Granite State. It appears that the first quarry in town was started in 1810 by Peter Burns. The industry did not really take off until the railroad came to town in the 1850s. The granite industry peaked in Milford between 1890 and 1930 and slowly declined after that due to more modern construction materials. Today, more than 190 years after the first quarry was established, there is still a working granite quarry in Milford. At least 15 abandoned quarries are strewn around the town. Milford granite has been used for monuments, paving blocks, statues, curbing, and building stone all over the United States. You can see the artistry and craftsmanship of Milford's finest stonecutters by simply strolling through some of Milford's cemeteries.

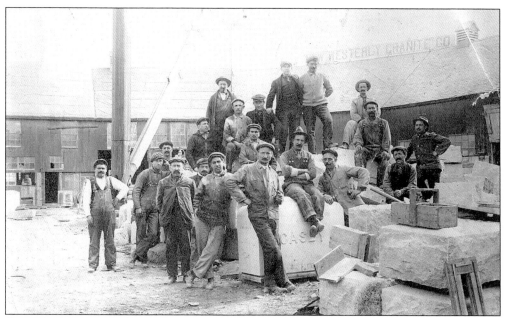

GRANITE WORKERS. The workers of the New Westerly Granite Company were responsible for the creation of monumental headstones that can be found in cemeteries across the country. The New Westerly quarry is located off North River Road and was used until the company ceased operations in 1948.

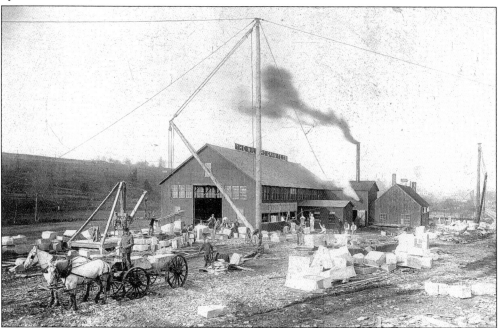

THE MILFORD GRANITE COMPANY. This undated photograph shows the cutting shed of the Milford Granite Company. The shed was located along the railroad tracks in East Milford. The company's quarry was opened in 1888 by Edward Kittredge and Charles Stevens. By 1909, the quarry had been purchased by B.A. Pease of Nashua. It was then known as the Pease Quarry and, in the late 1940s, was even a public swimming area.

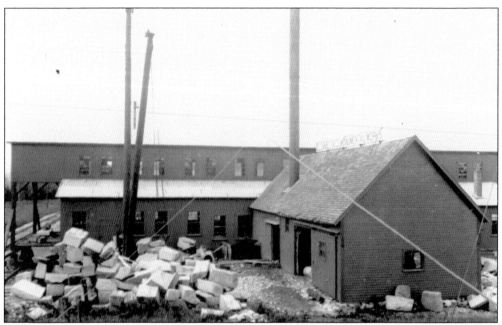

THE STONE SHED. This picture from 1911 shows the stone shed of the D.L. Daniels & Company Monumental Works on upper Oak Street. This company became the Souhegan Granite Company in 1913.

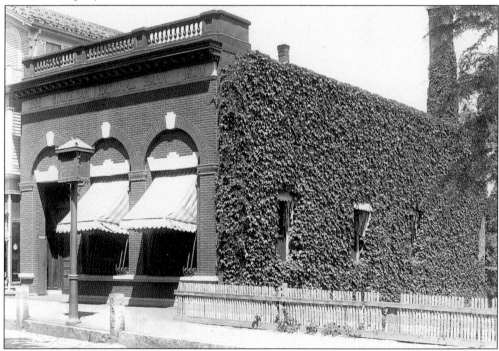

THE SOUHEGAN NATIONAL BANK. Before the addition to the bank in the late 1920s, this is how the building appeared. The east end of the building was completely covered with vines. The vines were eventually removed, and the building was expanded to its present-day width. Today, the bank building is home to the McBriarty Insurance Agency.

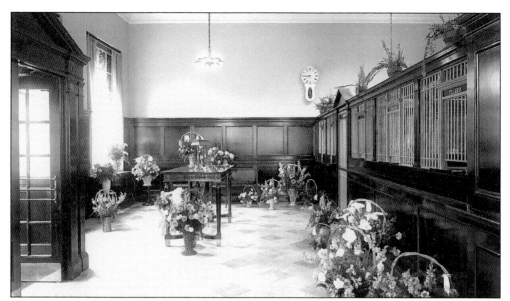

THE INTERIOR OF THE SOUHEGAN NATIONAL BANK. This picture shows the bank probably sometime after the building was expanded in the late 1920s. Before this expansion, the main door was to the west, with two windows to the east, as shown in the picture below. At this time, the interior of the bank was furnished in beautiful solid mahogany.

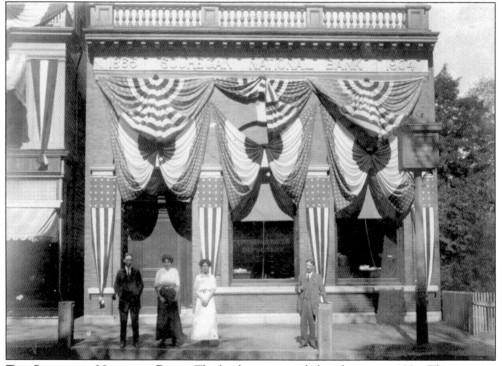

THE SOUHEGAN NATIONAL BANK. The bank was expanded to this size in 1904. The previous bank building was a much smaller structure, which can be seen on page 123. This undated photograph shows the employees of the bank. It may have been taken during the industrial carnival of 1911.

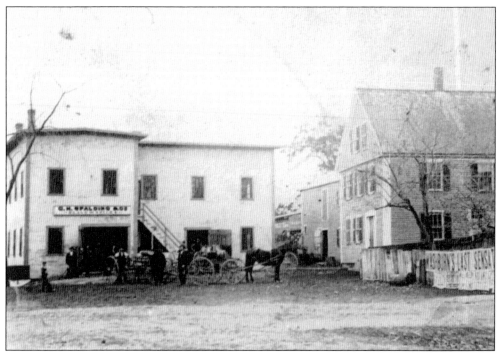

A BLACKSMITH BUILDING. Milford's second blacksmith shop was started here c. 1790. This picture appears to have been taken sometime in the 1860s. The buildings to the left were the blacksmith shop. The house was the residence of Granville Turner, one of the proprietors over the years. The blacksmith shop was torn down in 1943, and the site is now the home of the World War II memorial park near the entrance to Union Street.

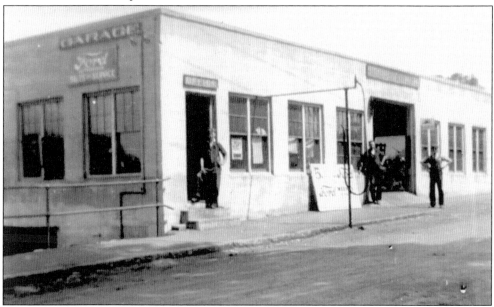

THE SOUHEGAN GARAGE. This undated picture shows the Souhegan Garage. The building is on Nashua Street across from Clinton Street. It was built on the site of the former Smith mill in 1912. Today, this location is the home of the Holt Insurance Agency.

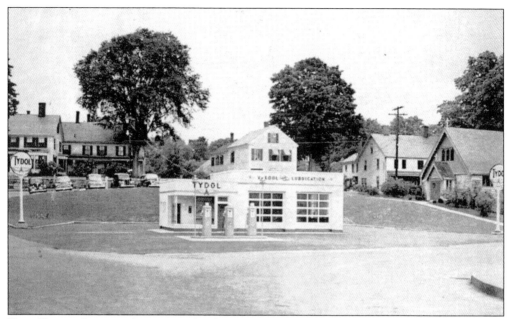

THE TYDOL SERVICE STATION. The former Whittemore Block was torn down in 1950 to make room for this new service station at the corner of Amherst Street just across the stone bridge. Although the operation has had many names over the years, it remains a service station today.

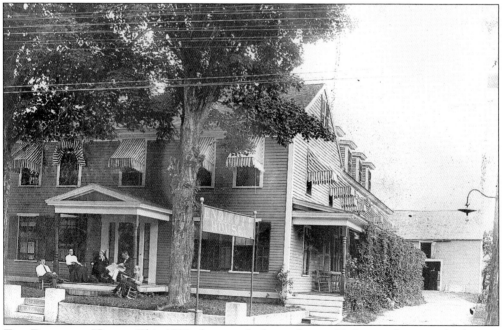

THE ENDICOTT HOUSE. This 1902 photograph shows the establishment that was also known as the Endicott Inn. The building in the back was a stable for housing the horses and carriages of guests. There were fires at the building in 1909 and 1915. It was repaired after both fires and became a private residence after the fire in 1915. It still stands today (minus the large ell) one lot to the west of Bales Elementary School on Elm Street.

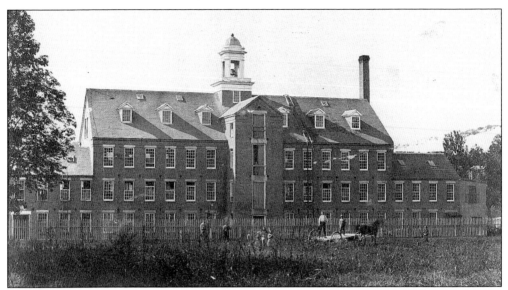

THE SOUHEGAN COTTON MILL. This large mill built for the processing of cotton was constructed in 1848 on the south side of Souhegan Street along the river. The building pictured was 178 feet long from end to end. The workers of the cotton mill built many of the older homes in the Souhegan Street area of Milford. The business ceased to exist after a fire completely destroyed the building in April 1872.

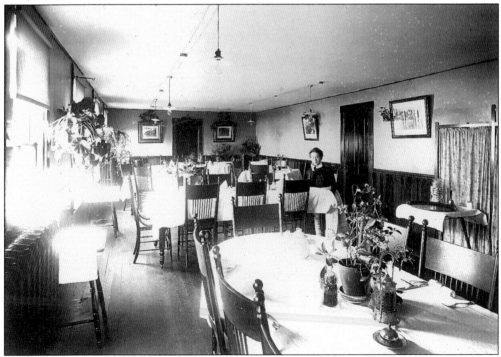

THE MILFORD INN DINING ROOM. This undated photograph shows the dining facilities at the business that was known over the years as Buxton's Tavern, the Union Hotel, the Howison House, and the Milford Inn. This photograph does appear to be from after 1903, as this was the year that electricity and central heating were added to the building.

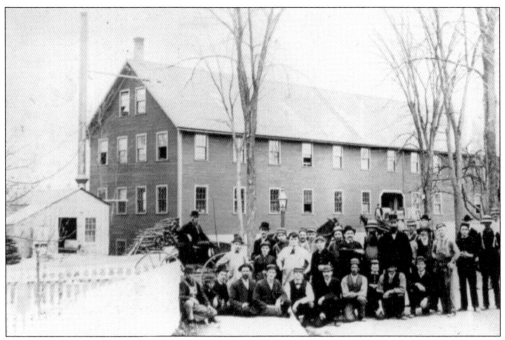

THE WILCOX MILL. This undated photograph shows the workers of the Wilcox Mill. The mill building shown behind them was located on Nashua Street directly across from the entrance to Clinton Street. The company manufactured various wood products. Like so many other old buildings in Milford, the building was destroyed by fire in 1887.

THE FULLER MILLS. Before these buildings became known as the McLane Manufacturing Company or the White Elephant Shop, they were known as the Fuller Mills. John McLane purchased the buildings in 1883, three years after starting his company, which manufactured post office equipment.

THE WHITE ELEPHANT SHOP. "Anything from a collar button to an elephant" was the saying painted on the side of the building on Nashua Street. The world-famous White Elephant Shop was operated by Harold Reed of Newport. The business was located in the former McLane Manufacturing Company buildings, today (and since 1970) the site of Cumberland Farms. The antiques and second-hand shop claimed to have one and a third acres of floor space and sold just about anything you could imagine. The business and the building were completely destroyed on a cold and icy night on January 23, 1966, when it burned to the ground. The glow from the flames could be seen from as far away as downtown Brookline. A similar type of business, called the Crazy Tee-Pee, operated on the west side of town next to the old Hayward Farms Restaurant. It ceased to exist sometime in the 1980s. The site of Hayward Farms Restaurant and the Crazy Tee-Pee is now approximately where Agway is on Elm Street.

Two

THE PEOPLE

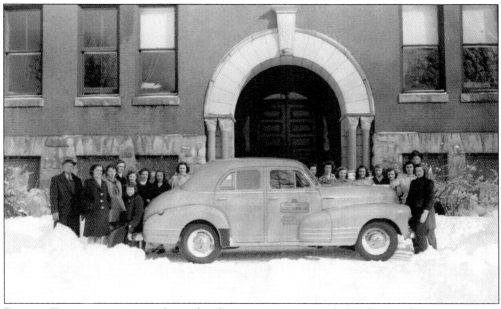

DRIVER EDUCATION. Pictured are the driver-training car and the driver education students at the high school in 1948. From left to right are ? Draper (car donor), Edith Jones, Esther O'Donnell, Ruth Carlson, Lucille Paro, Amelia Ciampo, Natalie Devine, Marian Blanchard, Joan Provasoli, Priscilla Conti, Joan Anderson, Shirley Langille, Doris Corey, Dolores Hayden, Claire Calderara, Lorraine Trombly, and Raymond Camp (instructor). Seated on the bumper is Nancy Fitch.

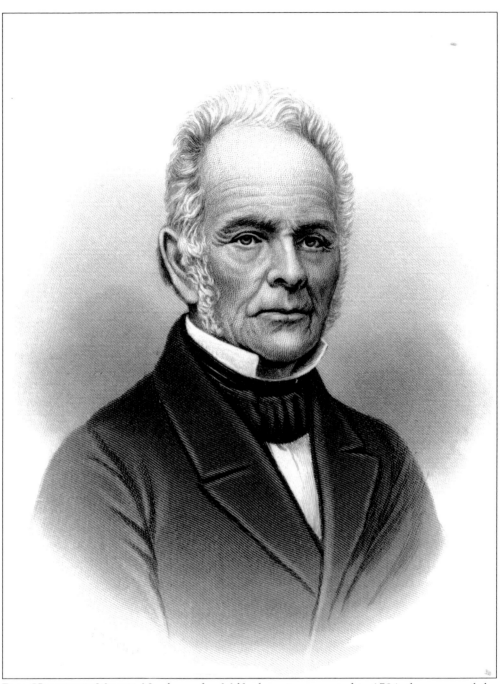

REV. HUMPHREY MOORE. Not long after Milford was incorporated in 1794, the town and the First Congregational Church of Milford worked hard to find a minister. Rev. Humphrey Moore was obtained in 1802 and became the town's first minister. Moore had a farm on Elm Street, and the Humphrey Moore house still stands today across the street from X-Tra Mart on Elm Street. Moore became a longtime resident of Milford and served as a businessman, a teacher, and a minister, as well as wearing many other hats. He died in April 1871 and, to this day, is one of the most important residents this town has had.

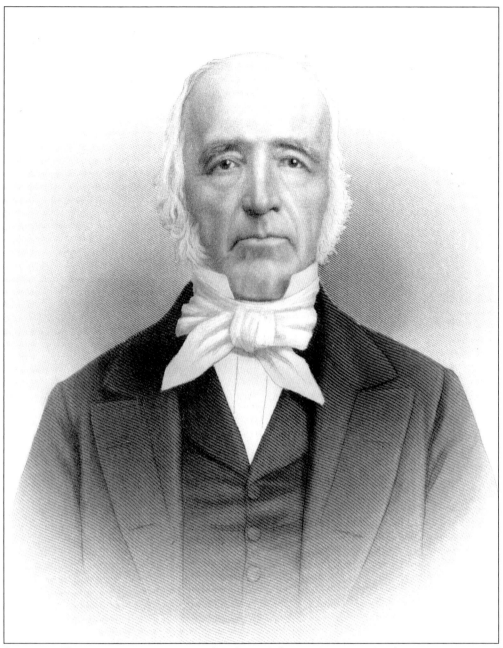

SOLOMON K. LIVERMORE. A native of Wilton, Solomon K. Livermore became a citizen of Milford in 1809. He graduated from Harvard College in 1802. His law practice was opened in Milford in 1809 and continued to operate until 1850, when he turned his practice over to Bainbridge Wadleigh. Livermore owned the farm that existed on the land that is now between Union, Elm, Cottage, and Garden Streets. His original house on this property sat about where the community house lawn is today. In 1832, he built his office building across the street on the lawn of the Congregational church, which can be seen on page 92. In 1842, he built today's community house as his primary residence. The former house was eventually moved and is today part of the house on the corner of Orange and Union Streets.

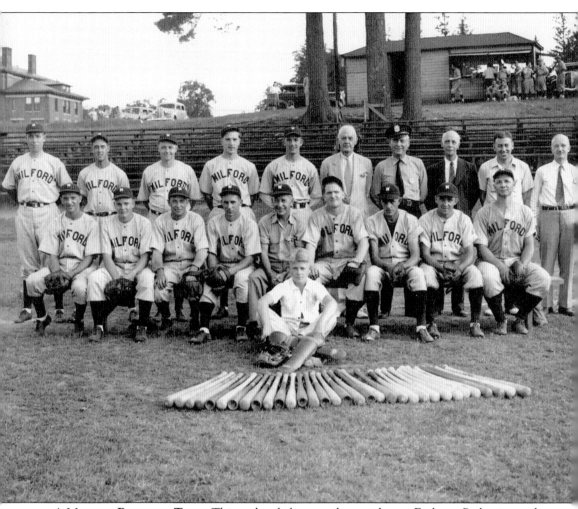

A MILFORD BASEBALL TEAM. This undated photograph was taken at Endicott Park prior to the construction of Jacques Memorial School. In the front sits an unidentified batboy. The others are, from left to right, as follows: (front row) Nick Calvetti, Merton Byrd, Bill Randall, Ruland Sears, Dave Daniels, Ralph Beard, Dick Ball, Novat Bergeron, and Dana Gangloff; (back row) Roy Claire, Dick Miller, John Stoddard, George Goulet, Frank Jewett, Tom O'Neil, William Gangloff, James Villane, and Fred Kimball.

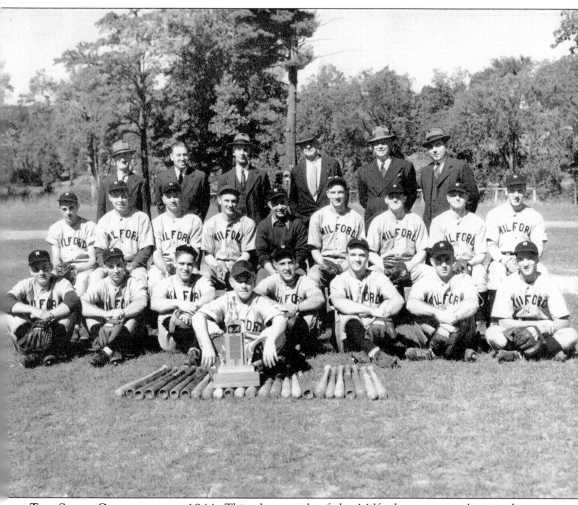

THE STATE CHAMPIONS OF 1944. This photograph of the Milford team was taken in the summer of 1944. From left to right are the following: (front row) Merton Byrd, Ruland Sears, Tuffy Desjardais, Dick Miller, Duncan Chaplick, Novat Bergeron, and Nick Calvetti; (middle row) Dick Ball, Roy Claire, Dana Gangloff, Stan Kubicki, coach Dave Daniels, George Goulet, Ralph Beard, John Stoddard, and Frank Gaidmore; (back row) Fred Kimball, James Vilbane, William Gangloff, Frank Jewett, Tom O'Neil, and Winston Hanlon.

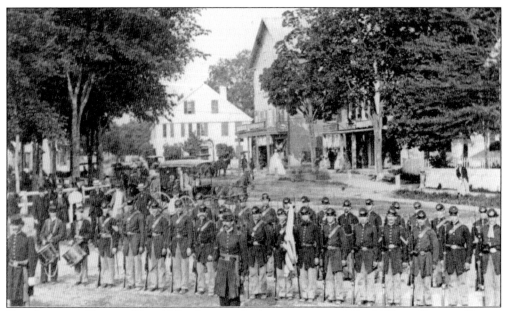

THE LINCOLN RIFLES. This 1861 photograph shows a group of Civil War soldiers in Union Square. The caption on the picture reads, "Lincoln Rifles 1861." There were 196 Milford men who entered the army during the Civil War.

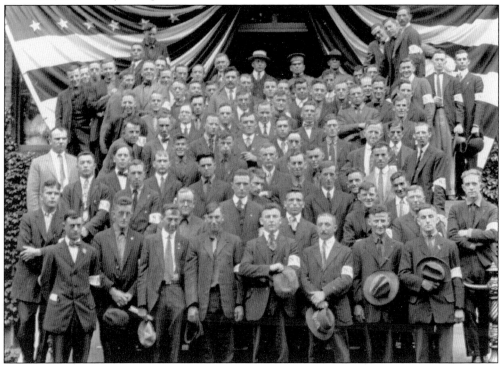

WORLD WAR I. A large group of Milford servicemen gathers *c.* 1917 before departing for Fort Devens. Seven men from Milford lost their lives in World War I—Andrew Ansaldo, Carlo J. Calderara, Louis Sumner Hartshorn, John William Johnson, James W. O'Neil, Rosario Riccardi, and Arnold Nannaford Wheaton.

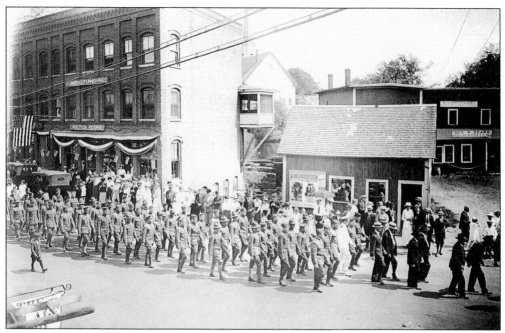

MILFORD'S SIGNAL CORPS UNIT. This photograph, taken during World War I, shows a parade with Milford's Signal Corps. During the war, these men saw active duty in Texas, South Carolina, and eventually in France, Luxemburg, France, and Germany. They returned to the United States in 1919 and were discharged.

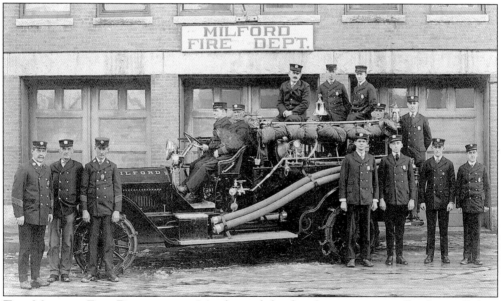

THE MILFORD FIRE DEPARTMENT. Members of the fire department proudly show off their brand-new mechanized fire engine in 1920. From left to right are the following: (standing) Leon C. Hall, Frank Jewett, Jerry Casey, John Martin, John Casey, Robert Brahaney, and Arthur F. Dutton; (on the truck) an unidentified driver, Carl Webster (beside the driver), Eugene Dutton, an unidentified person, Frank Grimes, an unidentified person, Clarence Seavey, and Will Sears.

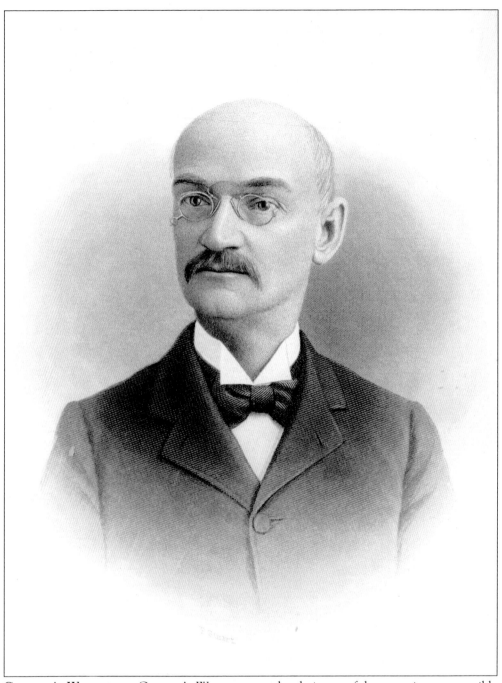

GEORGE A. WORCESTER. George A. Worcester was the chairman of the committee responsible for publishing the town history in 1901. He was very interested in the history of Milford and was the secretary and president for the Milford Historical Society. He was also a member of the New Hampshire Historical Society. He was born in Greenfield in 1852. He went to work for the French & Heald factory at the age of 13 and worked there for 25 years. He was very active in the Milford Baptist Association and served as clerk for many years. Worcester was also a town selectman for many years.

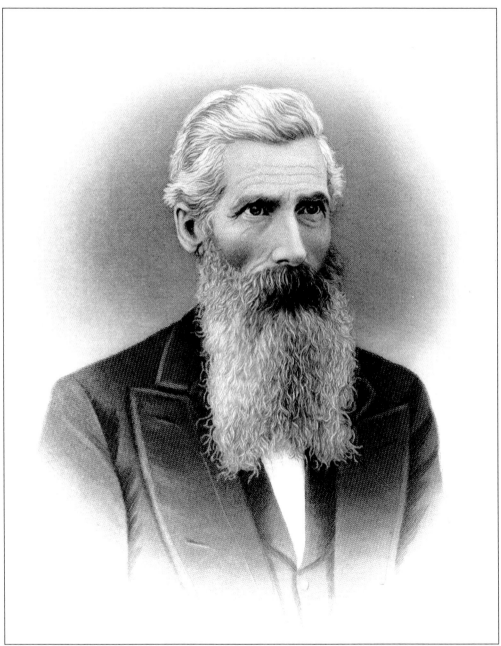

FREDERICK SAWYER. Although Frederick Sawyer did not take up residence until he was in his mid-30s, he remained a resident and business owner in Milford until the time of his death in 1898. He was born in the town of Bradford in 1819 and first began his career in that town as a clerk at a general store. Before coming to Milford, he had businesses in Nashua and Chelmsford. When he first arrived in Milford, he served for two years as the station agent for the Nashua & Lowell Railroad. He also operated a general store in Milford with William R. Wallace. He eventually became the cashier for the Souhegan National Bank and was also the director of the bank for quite some time. He worked for the Souhegan National Bank and was Milford's town treasurer until the time of his death.

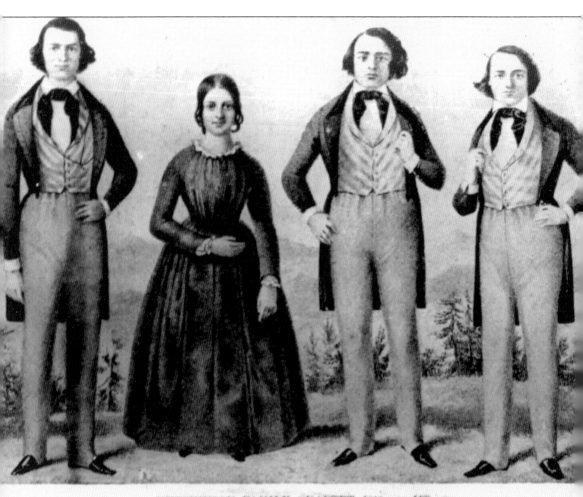

HUTCHINSON FAMILY QUARTET, 1846 (p. 142)

THE HUTCHINSON QUARTET. Judson, John, Asa, and Abby Hutchinson were well-known performers around the world in the mid-1800s. This family quartet of singers entertained in Europe and the United States. The quartet traveled to England in 1845. Just before their opening concert in London, they were welcomed at the home of Charles Dickens. The quartet began performing together *c.* 1841 even though the Hutchinson family as a whole (there were 16 children) was performing before this time. In 1841, Abby, the only girl in the quartet, was only 12 years old. The quartet continued to perform until the death of Judson on January 11, 1859. John, the last surviving member of the Hutchinson singers, died in 1908 and is buried in the North Cemetery on North River Road.

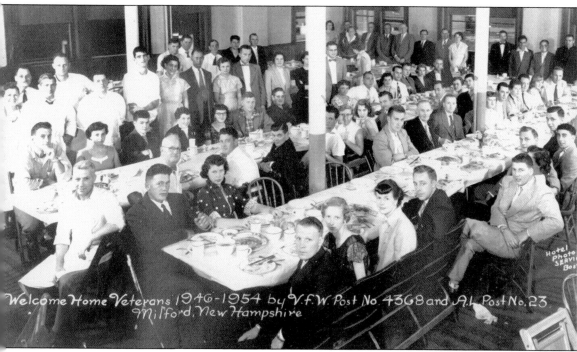

Welcome Home Veterans 1946-1954 by V.F.W. Post No. 4368 and A.L. Post No. 23
Milford, New Hampshire

Hotel Photo SERVIC Bos

A VETERANS CELEBRATION. This is a welcome-home celebration sponsored by the Veterans of Foreign Wars and the American Legion in Milford on Labor Day weekend in 1954. The event was for veterans from 1946 through 1954 and was held in the banquet hall on the second floor of the town hall.

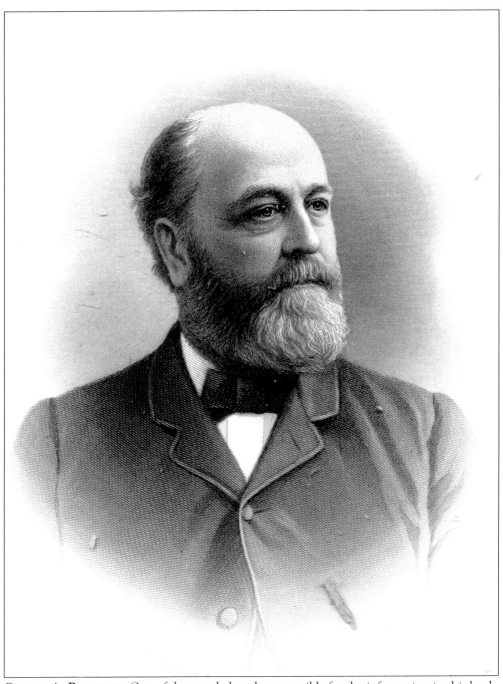

GEORGE A. RAMSDELL. One of the people largely responsible for the information in this book, George A. Ramsdell compiled *History of Milford, N.H. 1738–1901*. Ramsdell was born in Milford in 1834 and was a grandson of Milford's first minister, Rev. Humphrey Moore. Ramsdell was a lawyer and lived most of his life in Nashua. He also served as the governor of New Hampshire from 1897 to 1899. Ramsdell spent 10 years working on the town's history book and, unfortunately, died before the book was published. The residents of Milford will be forever grateful for the work of Ramsdell in preserving the very early history of the town.

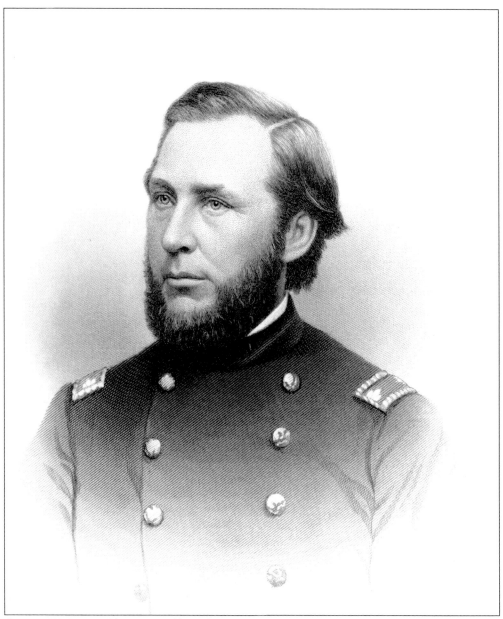

OLIVER W. LULL. Oliver W. Lull was born on January 14, 1826, in the town of Weare. After attending public schools in Weare and Manchester, he resided in Manchester and became a schoolteacher. His interest led him to the law. After getting a law education in Manchester, he was admitted to the bar in 1851. He ran a very successful law practice in Milford for the better part of 10 years. In 1861, Lull was among the first men in New Hampshire to volunteer his services in the Civil War. He was appointed as lieutenant colonel of the 8th New Hampshire Regiment. Unfortunately, he died from a wound sustained during the war while leading his regiment into battle.

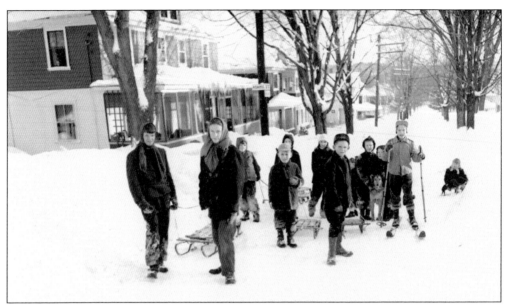

SLEDDING ON HIGHLAND AVENUE. These kids are taking advantage of a new coating of snow on January 25, 1948. They appear to be standing at the corner of Highland Avenue and Adams Street. The tradition of sledding on the hilled streets in Milford was commonplace 50 years ago, when there was much less automobile traffic than there is today.

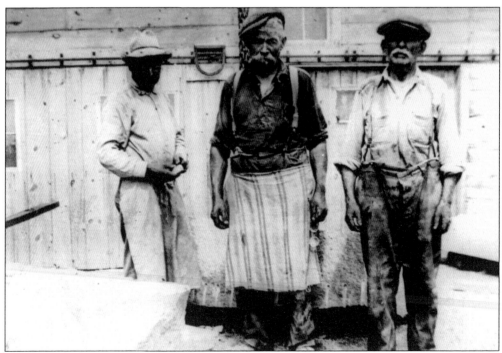

GRANITE WORKERS. This undated photograph shows some of Milford's early granite workers. Emilio Falcetti is in the center. Luigi Falcetti is on the right. The man on the left is unidentified.

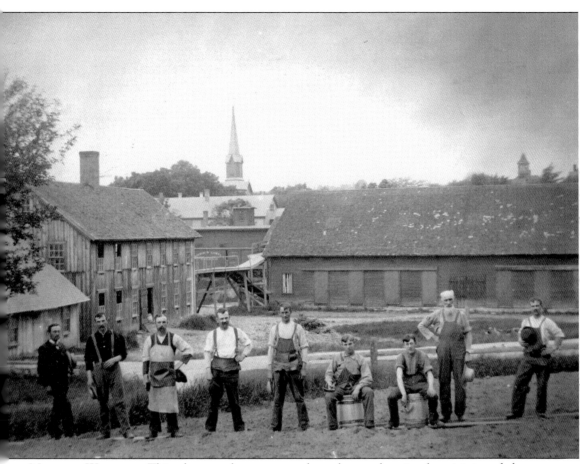

MILFORD WORKERS. This photograph appears to have been taken in the vicinity of the entrance to Prospect Street. The large steeple of the former Baptist church on South Street can be seen in the background. A boxcar can also be seen along the railroad tracks near the Fitchburg rail station. The men are unidentified.

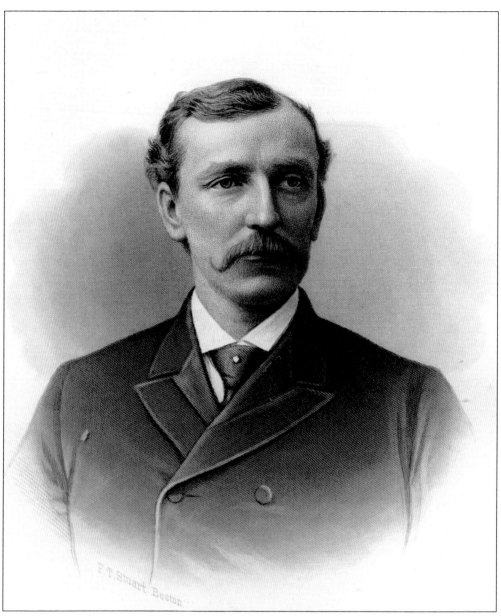

JOHN MCLANE. Born in Lennoxtown, Scotland, in 1852, John McLane moved to Manchester, New Hampshire, with his parents in 1854. By 1876, he had moved to Milford and started a basket-manufacturing company. In 1880, in addition to manufacturing baskets, his company started manufacturing post office equipment. He enlarged his business by opening another location in Chicago and by purchasing the mill buildings on Nashua Street, which later became the White Elephant Shop. During his life, McLane was active in town and political affairs. He was Milford's town moderator for 21 years and president of the Souhegan National Bank for 19 years. He served as a state representative and was a state senator. From 1905 to 1907, he served as the governor of New Hampshire. He died in North Carolina in 1911.

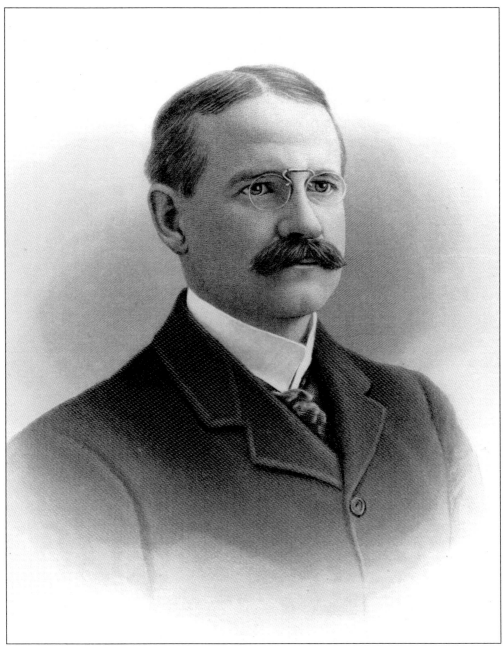

FRANK E. KALEY. Frank E. Kaley was born in Canton, Massachusetts, in 1856 and became a resident of Milford just four years later. He went to Milford schools and, at the age of 16, went to work for his father's company, the Morse & Kaley Manufacturing Company. In 1882, after his father's death, he became the treasurer of the company. Kaley held many positions in and around town during his lifetime. He was a director of the Souhegan National Bank and the director and vice president of the Milford Tanning Company. Kaley and his family moved away to New Jersey in 1907, when he was named vice president of the American Thread Company. Kaley died in 1922 and left about $800,000 to the town of Milford to set up the Kaley Foundation for educational and charitable benefit to the town.

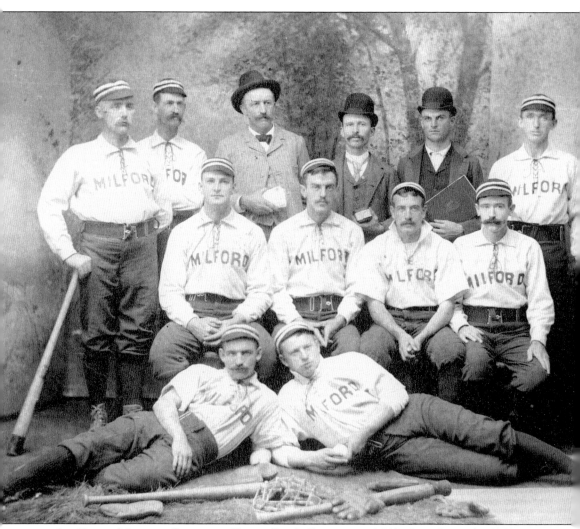

AN EARLY MILFORD BASEBALL TEAM. Baseball games in Milford in the early 1900s were a big deal and drew a large following. Dr. H.S. Hutchinson formed a team of local players. They called themselves the Milford Granites. Home games were played at Endicott Park on a diamond that was constructed by the players themselves. They took great pride in their baseball diamond and always ensured that it was kept in the best of condition. They mostly played town teams from other communities in southern New Hampshire and northern Massachusetts. The group was one of the best teams in New England for 25 years. This is an undated photograph of the Milford Granites. From left to right are the following: (front row) James Dillon and Ed Hartshorn; (middle row) James Howison, Frank Jewett, J.T. Young, and Jack Calahan; (back row) George McIntire, Arthur Howison, Dr. H.S. Hutchinson (manager), Will Pond (umpire), Benton Mills (scorer), and James Brahaney.

Three

UNION SQUARE
AND THE OVAL

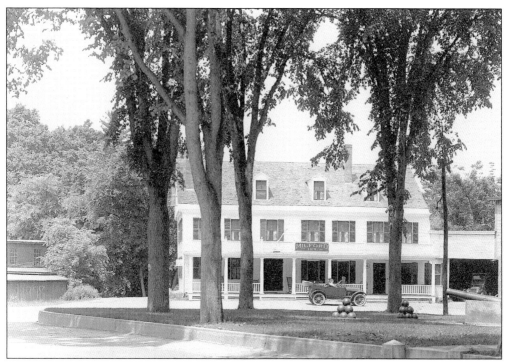

THE MILFORD INN AND THE RIFLE CANNON. A one-time icon on the west side of Union Square, the Milford Inn served as many as 7,000 guests in 1919. This photograph also features the Civil War rifle cannon and cannonballs that decorated the Oval between 1901 and 1927. This cannon joined another on the Lullwood estate on Nashua Street. Both cannons were eventually used as scrap iron for munitions during World War II.

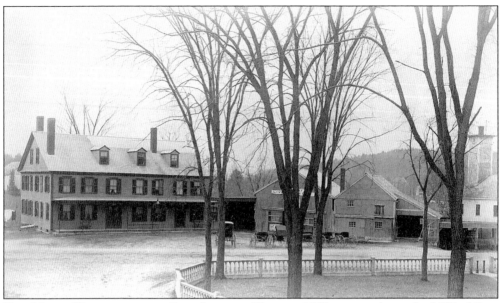

THE UNION HOTEL AND THE FIRE STATION. This pre-1893 picture shows the Milford Inn, the inn's stables, and the fire department building with its tower. The fire department building was constructed in 1857 and was Milford's first. The tower on the back of the building was 62 feet high and was used to hang the fire hoses to dry.

THE BUXTON'S TAVERN STABLE BUILDINGS. These stables were the place to go in the 19th century if you needed to hire a horse and carriage. If you were coming into town via train to stay at the tavern, a horse and carriage team from these stables would pick you up at the train station. This photograph also shows the decorative fence that surrounded the Oval from 1872 to 1893, when the existing granite curbing was put in place.

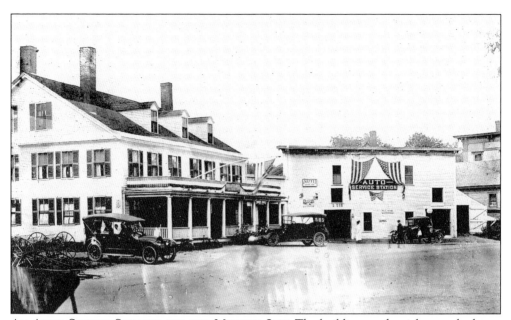

AN AUTO SERVICE STATION AND THE MILFORD INN. The building on the right was the horse stables of the Milford Inn for many years. Edward Albee was the owner of the inn at the time this picture was taken in the early 1920s. Albee removed the peaked roofs of the stables and remodeled the stables as one building with a flat roof. This became Milford's first automobile service station.

A BUXTON'S TAVERN AERIAL VIEW. This is another one of the pictures taken from the steeple of the Baptist church on South Street. It shows Buxton's Tavern on the west side of Union Square. Two of the houses on the south side of Union Square can be seen at the bottom of the picture.

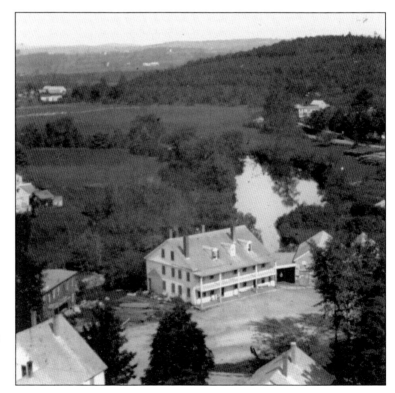

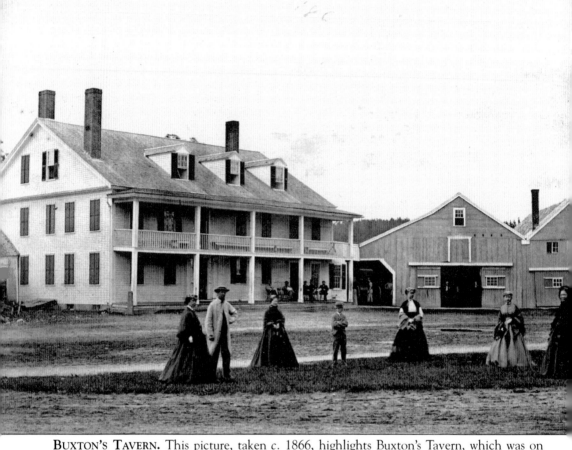

BUXTON'S TAVERN. This picture, taken *c.* 1866, highlights Buxton's Tavern, which was on the west side of Union Square for about 172 years. From left to right are Susan Buxton, James Buxton, Rhoda Parker, Charles Parker, Georgia Buxton Allen, Clara Pearson, and Mrs. Luther Pearson. The establishment had many owners over the years, and its names included Buxton's Tavern, the Union Hotel, and the Milford Inn. The building was completely destroyed by fire on May 3, 1959. Today, this spot is taken up by Foodee's Pizza and Ralph's Service Station.

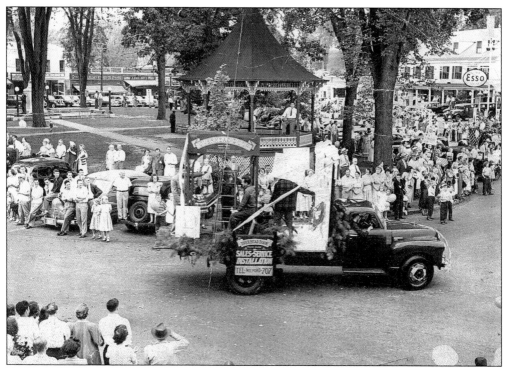

EVERYONE LOVES A PARADE. The Oval has seen hundreds of parades and events over the years. This picture is from the Labor Day parade in 1948.

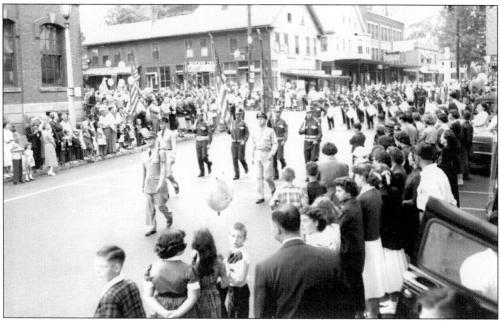

A LABOR DAY PARADE. This picture was taken on September 1, 1952, by longtime Milford resident and photographer Bernice Perry. The view here has not changed much in 50 years, with the exception of the building on the corner of South Street and Nashua Street being only one story tall now with a flat roof.

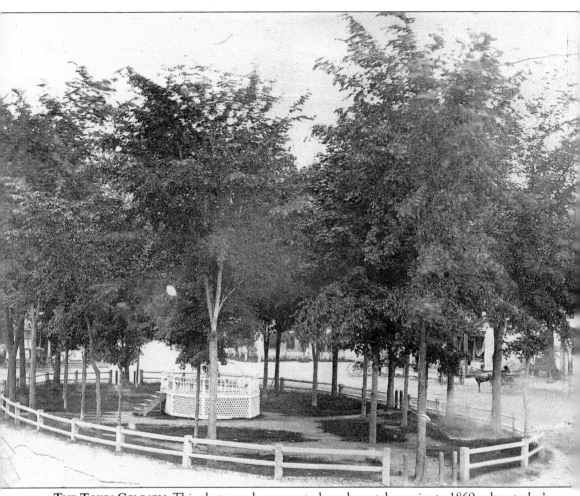

THE TOWN COMMON. This photograph appears to have been taken prior to 1869, when today's town hall was built. The houses to the right are on the south side of Union Square. Just over the bandstand is the corner of South and Nashua Streets. At this time, the common was oval instead of today's shape. It was also much smaller, as Eagle Hall (the town hall at that time) was just to the north of the common and faced south. When Eagle Hall was moved to its current location in 1869, the common was enlarged to its current size.

BEFORE THE TOWN HALL. Shown is another view from just before 1869, when the town hall was built. The building on the right is at the corner of Nashua and South Streets. To the left of that is Nashua Street. The small building hiding behind the trees to the left of Nashua Street is Mary Tucker's bonnet shop, which was owned at this time by Lucinda Hutchinson. The next building to the left is the Crosby house.

AFTER THE TOWN HALL. This photograph was taken just after 1869 from the same vantage point as the previous picture. The big difference is that this view includes the town hall in the background. Although this picture does not have a date on it, it may have been taken during the final stages of construction of the town hall.

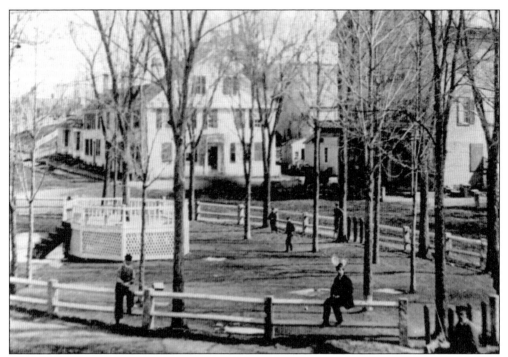

THE EARLY OVAL. This undated photograph shows many people on the Oval, with a few of them sitting on the fence that surrounded the common at that time. This particular fence appears to have been constructed in 1849. It was a split-rail fence and was supported by granite hitching posts. A new fence was built in 1872 and remained until 1893, when the existing granite curbing was put in.

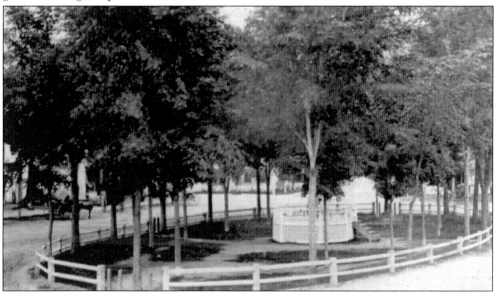

WHAT'S IN A NAME? This picture was taken in the same period of time as the last three photographs—right around the time the town hall was built. The photograph appears to have been taken from in front of the town hall lot, looking to the west. The shape of the common in this picture answers the question of how the Oval got its name.

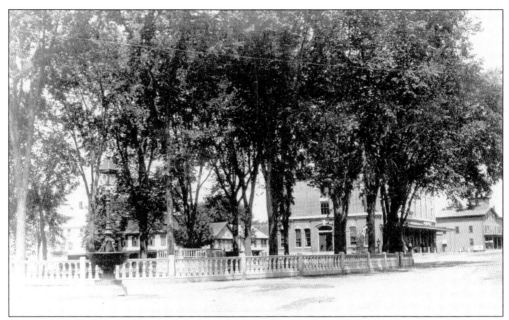

THE IRON WATERING TROUGH. This photograph, taken from the southwest end of Union Square, shows the iron watering trough that stood near the Oval for many years. The picture was taken sometime prior to 1893, when the granite curbing was installed on the Oval. The fountain was eventually replaced. It was then moved to the pumping station on South Street and was later stolen.

THE STONE WATERING TROUGH. After the iron watering trough was moved, this stone trough was put in its place. After years of being lost, the stone trough is now at the corner of Union and Elm Streets and is dedicated to longtime Milford historian Winifred A. Wright. This photograph was taken in 1928 soon after the Dr. Herbert Stillman Hutchinson house, on the south side of the Oval, was demolished and before the existing brick block was built that same year.

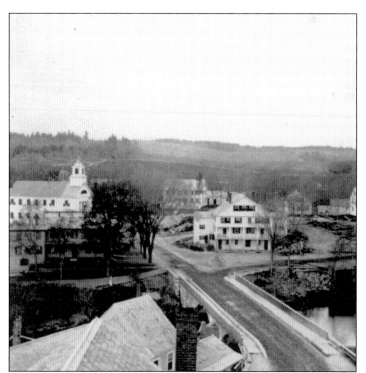

THE WHITTEMORE BLOCK. This photograph appears to have been taken prior to 1869. The picture gives a good idea of where Eagle Hall once stood, because it was taken from the peak of the building before it was moved to its current home. The building just across the bridge was called the Whittemore Block, named after one of its owners, William Lewis Whittemore. He was a well-known educator in the 1800s and early 1900s.

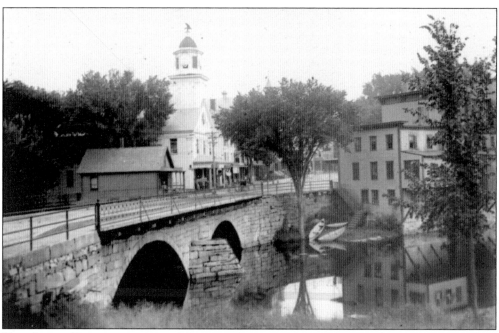

THE STONE BRIDGE FROM THE NORTH. This picture was taken in the vicinity of today's Emerson Park. The building on the other side of the road on the south end of the bridge is today's dining room of the Milford Diner. It has housed many businesses over the years, including Mrs. Sabin's variety store, Adams' barbershop, and the Ladies Exchange (from 1892 to 1907).

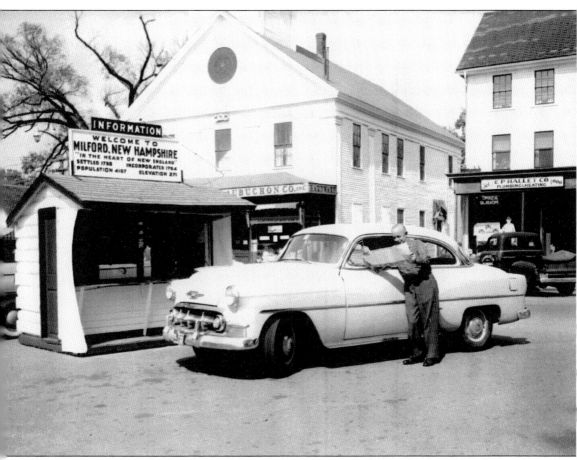

THE INFORMATION BOOTH AND EAGLE HALL. The sign on top of the information booth states that the population of Milford was 4,167. Milford's population has tripled since this picture was taken on August 4, 1954. Many New England towns had information booths like this one in the 1940s and 1950s. This booth sat just off the north end of the Oval. Eagle Hall, the original meetinghouse for Milford, can be seen in the background. It served as the town hall for Milford from 1834 to 1869, when the existing town hall was built. At this time, Eagle Hall was moved to the lot of land on which it still stands today.

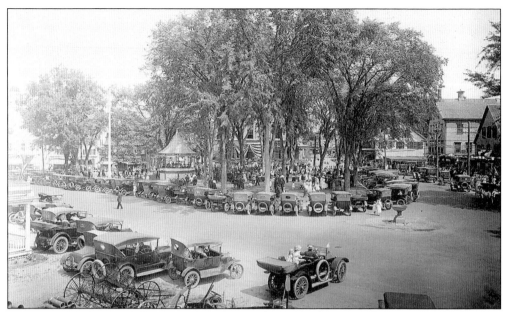

WELCOME HOME DAY. On August 23, 1919, the town threw a celebration for the troops returning from World War I. At the time this picture was taken, the Salem Cadet Band from Boston was performing on the bandstand.

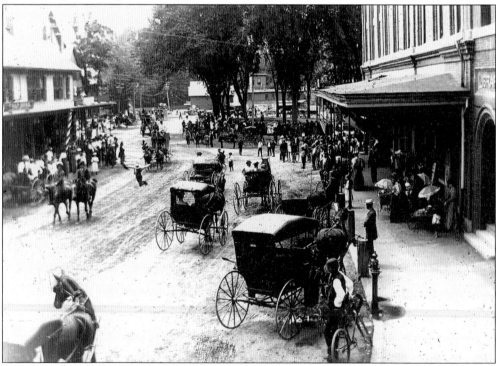

NASHUA STREET AND UNION SQUARE. Before the popularity of the automobile, horse-drawn carriages, as shown in this *c.* 1906 photograph, were the main means of transportation. This view also highlights the wooden awning on the Nashua Street side of the town hall. The awning was built in 1870 and was removed in 1932.

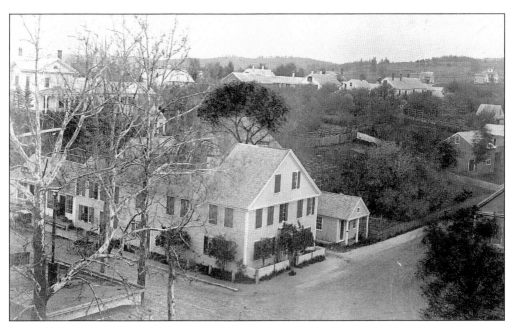

THE CORNER OF SOUTH STREET AND NASHUA STREET. It would appear that this house was built prior to 1797. This is the same building that stands on the corner today. Gilbert Wadleigh purchased the building in 1881 and remodeled the street level into space for four stores. In 1969, Salvatore Crisafulli had the building cut down to its current status of one floor. This picture was taken before the current town hall was built in 1869.

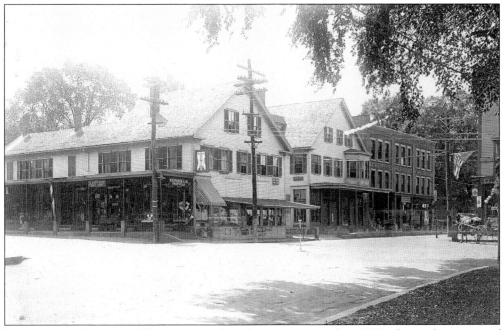

DENTISTS IN MILFORD. This photograph, taken sometime after 1893, shows the corner of South and Nashua Streets. The very noticeable dentist sign was an advertisement for the dental office of Fred M. Wetherbee, a lifelong resident of Milford. Wetherbee died on Christmas in 1959 at the age of 96.

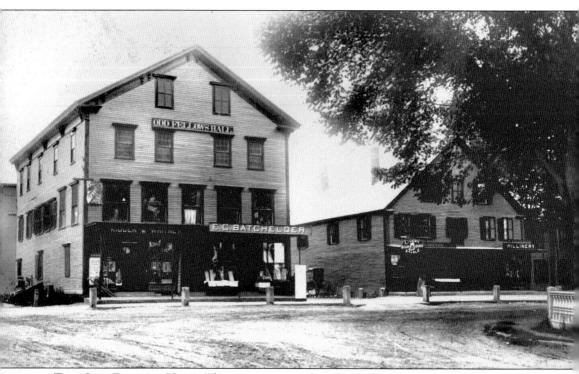

THE ODD FELLOWS HALL. This picture was taken from directly in front of the town hall sometime prior to 1893. The building on the left was then the Odd Fellows hall upstairs, with businesses on the floor level. Raymond Dyer purchased the building in 1929, and Dyer's drugstore was located in the west store space for several decades. The east space was the Kidder and Whitney drugstore and hardware store for 53 years. Through the 1960s, 1970s, and 1980s, this east space housed Darling's Gift Shop. Dyer removed the top floors of the building in 1965, and a flat roof was built. The building has been mostly unchanged since.

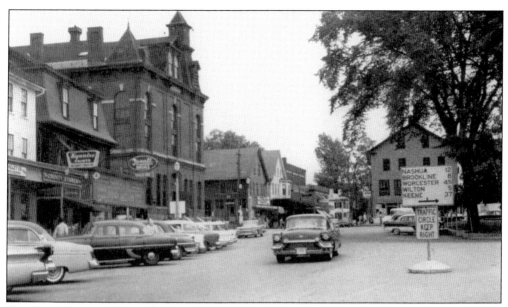

THE EAST SIDE OF UNION SQUARE AND SOUTH STREET. By the looks of the automobiles, this photograph appears to have been taken in the 1950s. The businesses in the Crosby house at this time were Edward Hallet Plumbing and Heating in the north space and the County Stores in the south space. The block on the corner of Middle Street housed the Rexall Pharmacy.

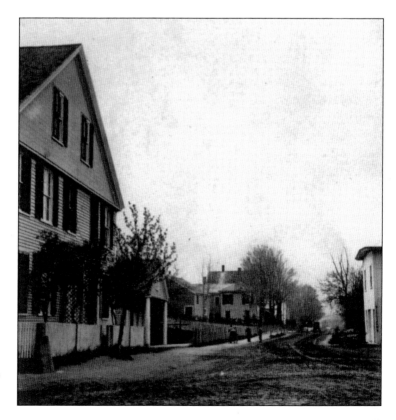

THE SOUTH STREET ENTRANCE FROM UNION SQUARE. This photograph dates from 1865 or earlier. The house on the left is on the corner of South and Nashua Streets. The small building just after it was the office of Dr. S.S. Stickney. After 1878, it was used as a home. Sometime after 1889, it became part of a house on Oak Street.

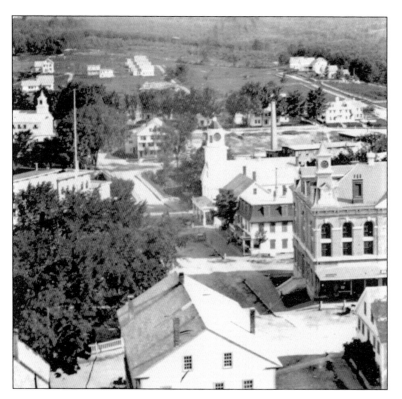

DOWNTOWN MILFORD AND THE HIGHLANDS. This photograph, taken from the Baptist church steeple, shows the corner of South and Nashua Streets at the bottom right. The Methodist church can be seen on the corner of Mont Vernon Street. The three streets at the top of the picture are, from left to right, Myrtle Street, Highland Avenue, and Summer Street.

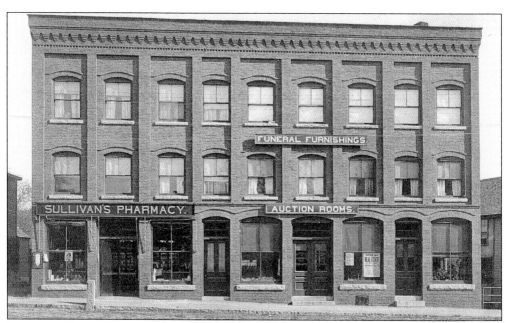

BENJAMIN FOSTER'S BLOCK. Benjamin Foster constructed this building in 1890 on the south side of Union Square. The two floor spaces have housed several businesses over the years. The west space was leased to Frederick Hicks in 1950, and a jewelry shop was opened. Hicks Jewelry has occupied this space for 52 years.

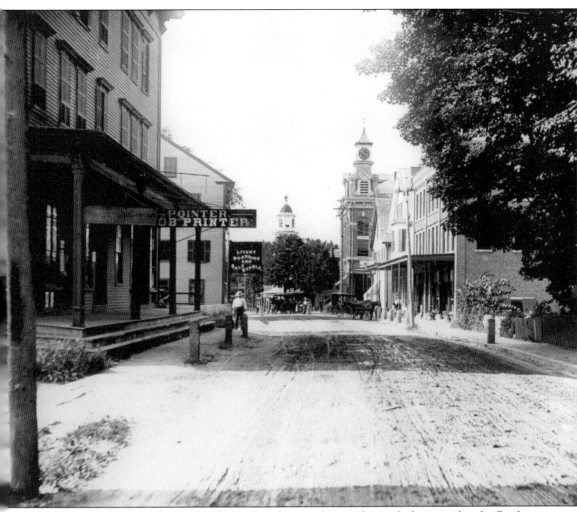

THE POINTER BLOCK. This undated photograph was taken in front of what is today the Bank of New Hampshire, looking north toward the Oval. The building on the extreme left of this picture was known as the Pointer Block. The building was constructed *c.* 1869 by Isaac Burns. The second floor became known as Burns Hall and was used for classrooms when Milford's schools became overcrowded. The *Daily Pointer*, a small newspaper, was published here from 1894 to 1906 by Edward Stanyan.

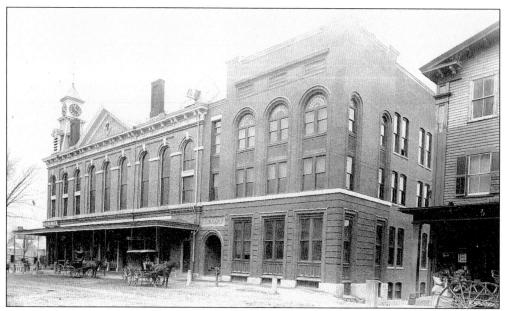

THE LIBRARY ANNEX. At the center of this picture is the library annex, which was built 23 years after the main town hall. Some $15,000 was appropriated for the construction of the annex at the town meeting in 1891. The second floor of the annex is the banquet hall, and the first floor was the library until the current William Y. Wadleigh Memorial Library was built in 1950.

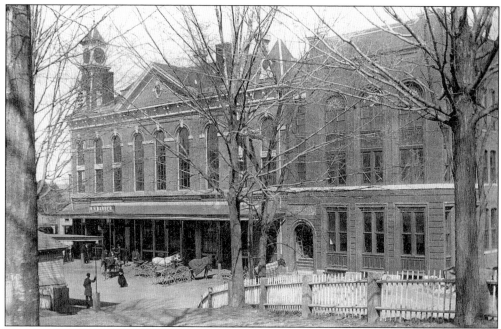

THE TOWN HALL. This photograph was taken sometime after 1982 from the lawn of the Lull estate on Nashua Street where today's library stands. The original building was built in 1869 at a cost of $55,000. The town hall belfry contains the 56th bell cast by Paul Revere. He cast 135 bells in all and, as of 1978, there were only 23 known to still exist.

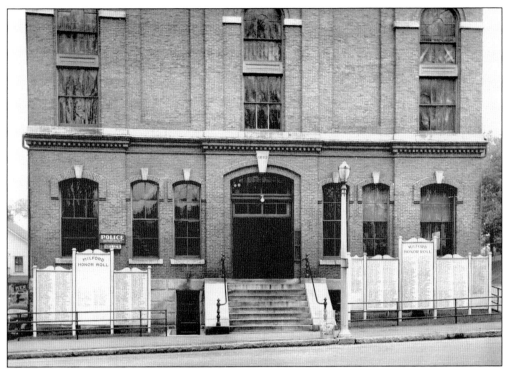

MILFORD'S HONOR ROLL. This undated picture shows the signs that were put up in front of the town hall during World War II. The signs contained the names of the 553 Milford men and women who served in the armed forces during the war.

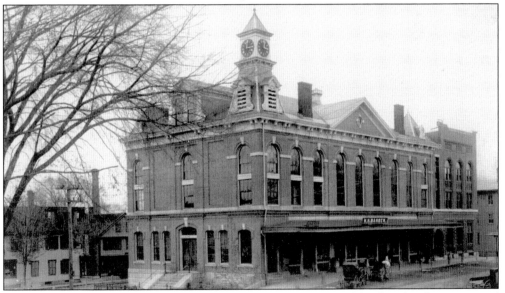

MILFORD'S TOWN HALL. In the early days of the town hall, most of the floor level was occupied by businesses. Calvin H. Averill ran his watch-repair and jewelry store. In this picture, the sign for H.H. Barber can be seen on the wooden awning. H.H. Barber ran one of the first department stores in town. The town hall also housed the Milford Police Department in its basement for many years.

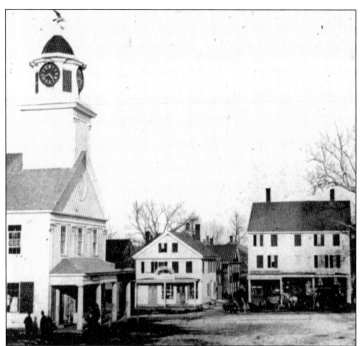

BEFORE THE UNION SQUARE CHANGES. This unique picture was taken prior to the construction of the town hall in 1869. Eagle Hall, which then served as the town hall, can be seen sitting in its old home. The three-story building with two chimneys is the Crosby house, which still sits on the east side today and houses the Fish Bowl and Hometown Insurance Agency. In this picture, taken before the Crosby house was moved, the building is sitting about where Middle Street is today.

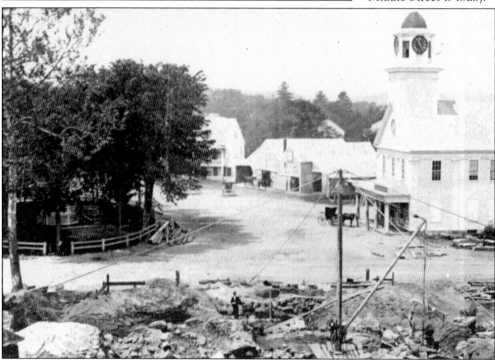

DURING THE UNION SQUARE CHANGES. When the people of Milford decided to build a new town house, they decided to build it on the corner of Nashua Street and Union Square. Two buildings had to be moved off the lot—the Crosby house and a smaller building on the corner of Nashua Street. These buildings can be seen in the previous photograph. This view shows what the town hall lot looked like once the buildings were moved to make room for construction.

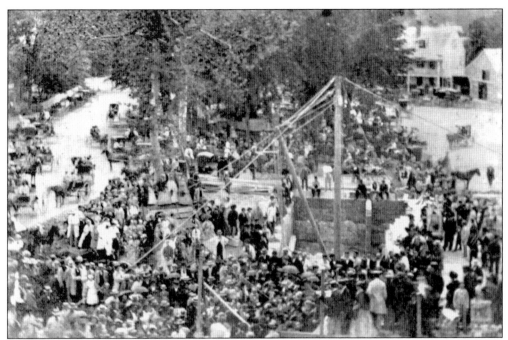

THE TOWN HALL CORNERSTONE. This photograph shows people gathering for the laying of the cornerstone of the new town hall in 1869. By the end of the Civil War, Milford had outgrown Eagle Hall as its town house and decided that it was time to build a new one. Many buildings were moved on the east side of Union Square to make room for the new town house.

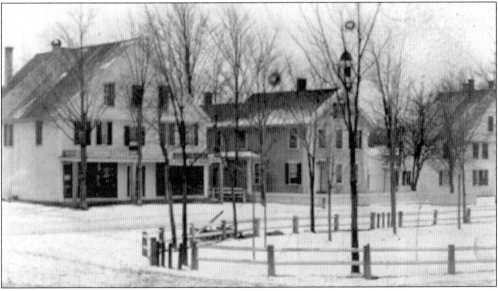

THE SOUTH SIDE OF UNION SQUARE. This appears to be one of the earliest photographs of Union Square and the Oval. The building on the left is the existing Stickney Block. The middle building was the home of Frank E. Kaley and was used by the Red Cross from 1917 to 1919. This house was torn down in 1937 by Demetrius Latchis to build a movie theater. The building on the right was the home of Dr. H.S. Hutchinson. It was torn down in 1928, and the current one-floor brick building was built.

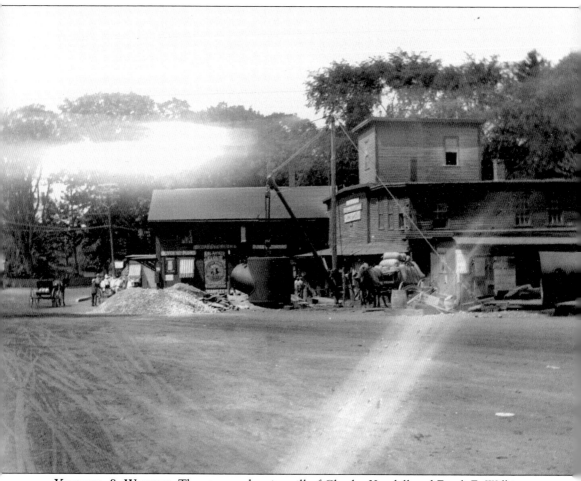

KENDALL & WILKINS. The store and grain mill of Charles Kendall and Frank E. Wilkins was located where the Texaco station is today on Union Square. As early as 1793, William and John Crosby owned this property and the original sawmill and gristmill buildings. With the coming of the automobile, the Kendall and Wilkins store became in 1903 one of the first establishments in town to offer gasoline. The store building was torn down in 1944. On the other side of the store, two stucco buildings were built in 1924. In 1929, Standard Oil bought the stucco buildings, tore them down, and built a brick Socony gas station, which was operated for many years by Paul Hutchinson. This station was removed for the present Texaco station, which is much larger, and its site includes the area where the grain store stood.

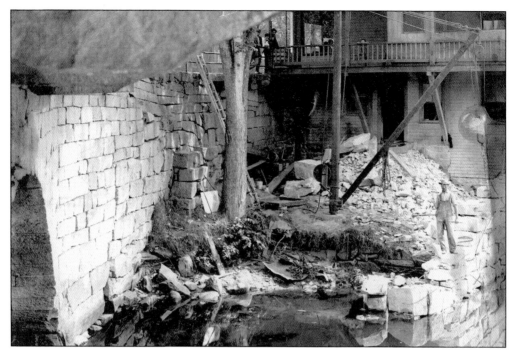

UNION SQUARE CONSTRUCTION. In this 1913 view, John T. Smith prepares his property on the west side of Union Square for a two-story addition and bowling alleys that would extend over the river. To the left is the stone bridge. Smith had to remove his bowling alleys when the bridge was widened in 1932.

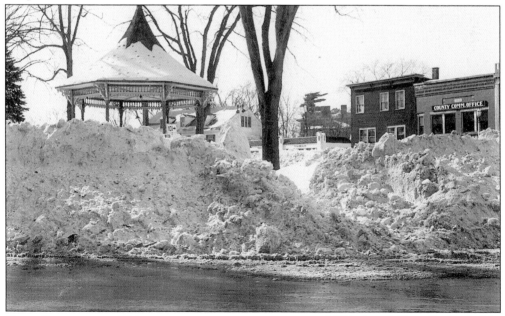

OVAL SNOWBANKS. Major snowstorms are no stranger to Milford and New England. The winter of 2000–2001 brought several large snowstorms. The Blizzard of 1978 brought 23 inches of snow to Milford and had schools closed for several days. This early-1940s picture must have been taken shortly after another large storm.

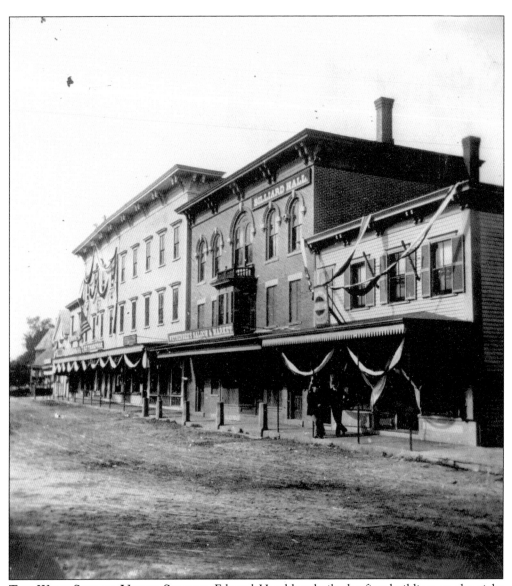

THE WEST SIDE OF UNION SQUARE. Edward Hamblett built the first building on the right sometime between 1867 and 1874. The second floor has housed a barbershop and the Milford Camera Club. It was on this second floor that the first game of basketball was played in town. The next building to the south has stood at this location since as early as 1838. From the time it was built until the brick school was built in 1853, it served as a Milford school building. In this photograph, the brick building is three stories high. It was remodeled down to two stories (as it stands today) in 1918 after a fire did major damage to the building on Christmas day in 1917. The ground level has housed numerous establishments over the years, including a grocery store and a saloon in the early 20th century. Today, the north space on the ground level is home to Flowers on the Oval.

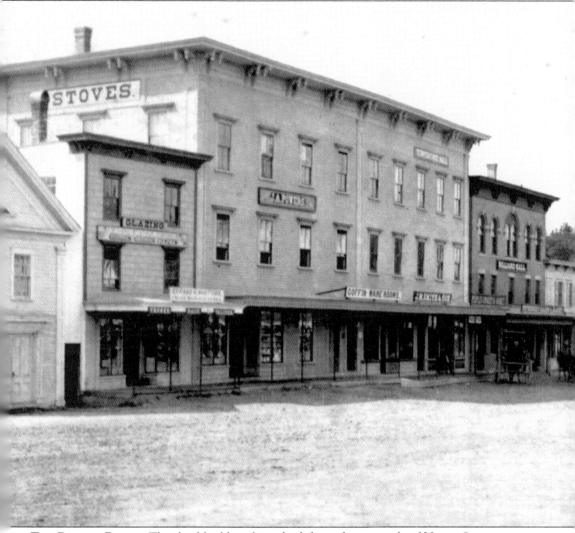

THE POWERS BLOCK. The third building from the left on the west side of Union Square was known as the Powers Block. Its original owner, John Powers, built it in the 1860s. The same building stands there today and houses the Riverhouse Café on the ground floor. The building was cut from three floors down to two after a fire destroyed the top floor in October 1929. The block to the right of it appears to be the same building but is not. For years, it was known as the Coburn-Hamblett Block. The existing structure was previously two separate buildings that were joined together. The building has had several owners and businesses over the years, including Joe Swiezynski and his barbershop.

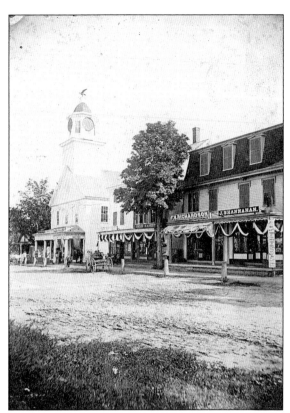

THE EAST SIDE OF UNION SQUARE. The block on the right has been on the corner of Middle Street and Union Square since sometime after the town hall was built in 1869. James Shanahan, who came to Milford from Ireland in 1855, built the block. Shanahan ran a shoe business in the corner lot until he passed away in 1915. Several pharmacies occupied this space until the late 1970s. Today, the corner spot is the home of A & D Computer.

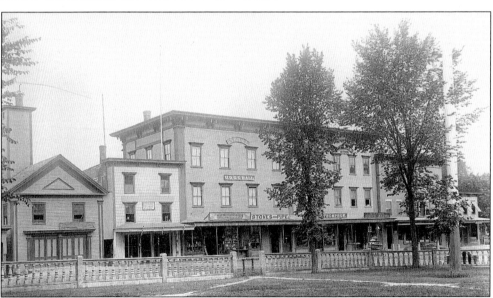

THE WEST SIDE OF UNION SQUARE. The second building from the left was known for years as the Canary Block because it was painted a bright yellow. The building was constructed c. 1870 and had many residents over the years, including the American Legion on the top floor in 1929. A fire damaged the building beyond repair on October 7, 1929. The brick block that now occupies this space was built in 1930–1931.

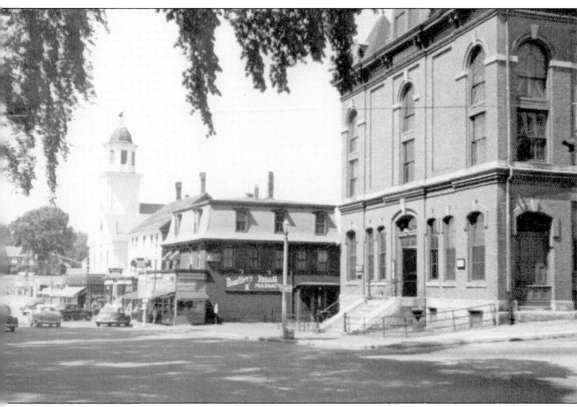

UNION SQUARE'S EAST SIDE. This photograph is from a postcard and appears to have been taken sometime in the 1950s. It highlights the east side of Union Square as well as the McLane house on Grove Street where Brooks is today. These buildings on the east side have housed numerous businesses since 1869, when most of them were moved to where they stand today. Eagle Hall was occupied over the years by grocery and hardware stores. For some 50 years, Aubuchon Hardware occupied this space. The old Crosby house (the next building to the south) has housed the County Stores, a meat market, a grocery store, plumbing and heating businesses, and today the Fish Bowl and Hometown Insurance Agency. Details on the building on the corner of Middle Street and Union Square can be found on the previous page.

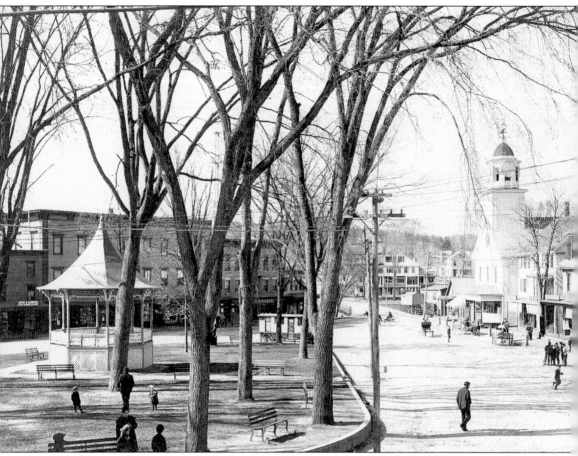

THE OVAL AND THE LUNCH CART. This photograph, looking north, shows the east and west sides of Union Square c. 1910. At this time, there was a clock on the Eagle Hall tower. Just off the north end of the common sits the lunch cart that was owned and operated by Fred Wilkins. The diner was eventually moved to the southwest corner of the stone bridge. A couple of years later, it took up residence on the southeast side of the stone bridge. Although it is a different building, the southeast side of the bridge is still occupied today by the Milford Diner.

Four

STUDENTS
AND SCHOOLS

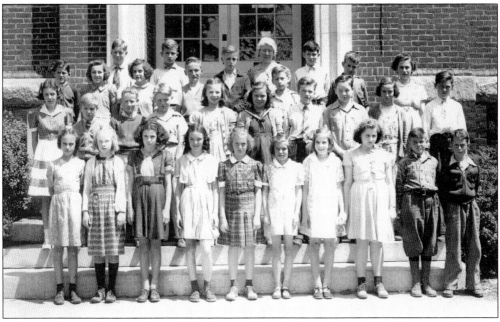

A SIXTH-GRADE CLASS, 1941–1942. Pictured, from left to right, are the following: (first row) MaryAnn Clark, unidentified, Dorothy Young, Elizabeth Johnson, Carol Tonella, Ada Mae Kimball, Ruth Flagg, Lucille Paro, Earl Townsend, and Merton Dyer; (second row) Corrine Field, John Walker, Paul Hutchinson, Edward Conley, Joanne Anderson, Jeanne Jacques, James Cooney, Mario Falsani, Mavis Davis, and James McEntee; (third row) James Gillis, Louise Picard, Shirley Langille, D. James Philbrick, Archie Carpentiere, and Lucille Donnecourt; (fourth row) Sherman Foote, Arthur Hendrickson, James Cahill, ? Draper, Herbert Gerry, and Harold Rand.

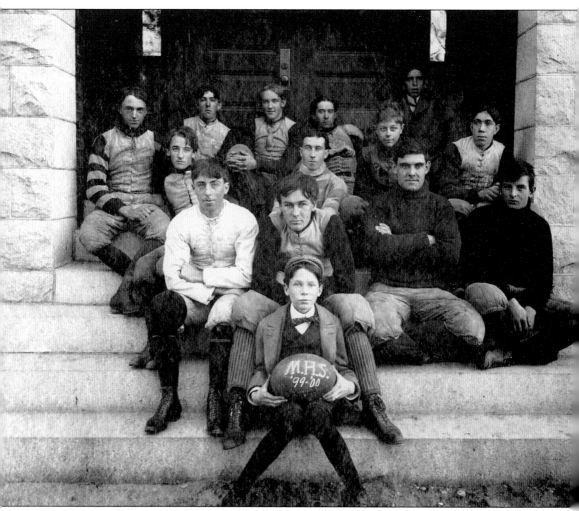

THE 1899 MILFORD HIGH SCHOOL FOOTBALL TEAM. Milford's new high school was only five years old when these players posed on the front steps. They are identified as fullback Otis Smith; quarterback Robert Wal; halfbacks John Bren and Ed Lynch; ends Arthur Richardson and John Anderson; tackles John ? and Harry Sanderson; guards Perce Kendall and Frank Thurston; center George Searles; and substitutes Charles Cheyne and Fred Young.

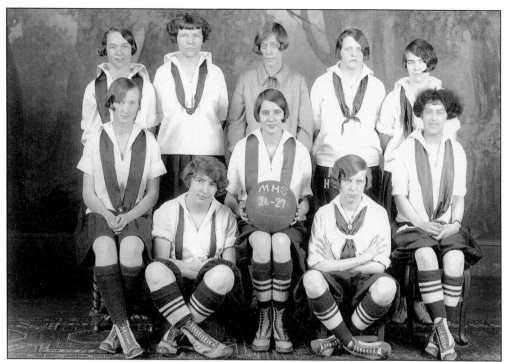

THE GIRLS' BASKETBALL TEAM. This photograph shows the Milford High School girl's basketball team of 1926–1927. From left to right are the following: (front row) Helen Thomas, Florence Dutton, Rita Stimson (captain), Mary Jameson, and Violet Boudreau Consigli; (back row) Peggy Deans, Bella Courage, Irma Andrews (coach), "Jerry" Parker, and Gertrude Wheeler.

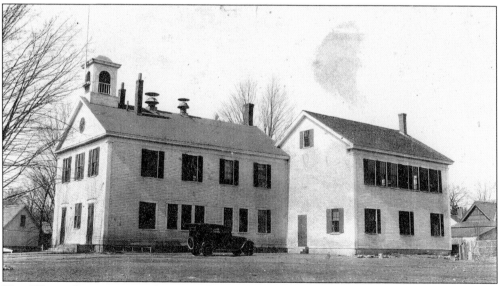

THE WHITE SCHOOL WITH ANNEX. The need for space in Milford schools is not a new issue. The Old White School, on Garden Street, was added to about 30 years after being built. Just two years later, in 1892, an addition was built onto the addition. Voters approved the building of the Garden Street School to replace the Old White in 1925.

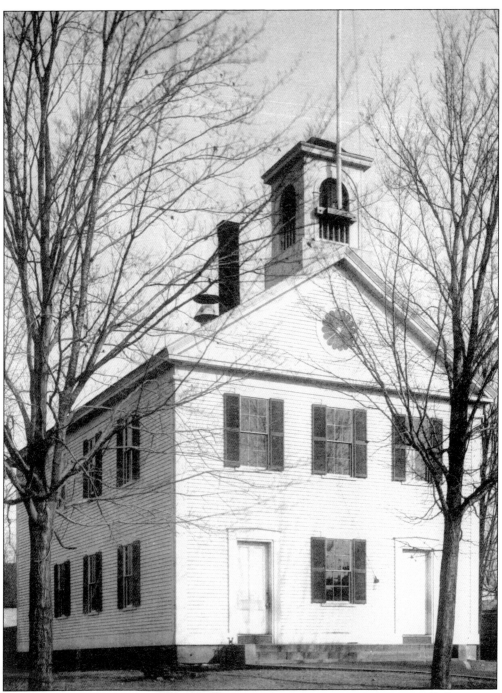

THE OLD WHITE SCHOOL. This schoolhouse was built in 1860 and was originally known as the Grammar and West Primary. It served the children of Milford for 65 years. The school was located on Garden Street just to the south of the existing Garden Street School. It was remodeled several times over the years, and a couple of additions were built in the late 1800s. The building was auctioned off for $480 in 1925 and was torn down to make room for the new Garden Street School.

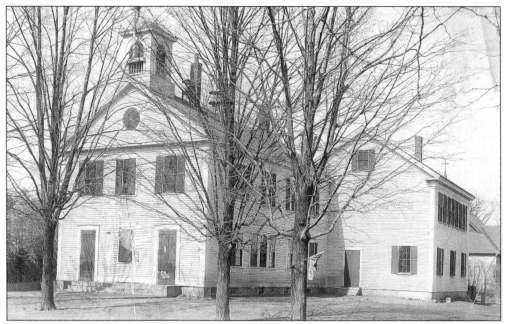

THE DISTRICT NO. 9 SCHOOL. Prior to the 1870s, Milford's school system was divided into several districts. These districts consisted of several very small schoolhouses, of which some are still standing today. District No. 1 covered the downtown area of Milford. It was divided in the mid-1800s, and one half of it became District No. 9. The Old White School (pictured) was the Grammar and West Primary for District No. 9.

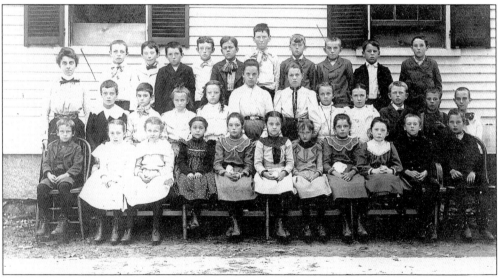

A FOURTH-GRADE CLASS, 1901. These children attended the Old White School, which was located where the Garden Street School is today. From left to right are the following: (front row) Lila Merrill, Emily Arnsden, ? Calderara, Christine Dodge, Josephine Calderara, Margaret Brahaney, unidentified, and unidentified; (middle row) Fred Bergami, unidentified, Barbara Kaley, Sadie Balcom, ? MacGrath, Hazel ?, Helen Chase, Margaret Rossiter, ? Dutton, Wendell Holt, and unidentified; (back row) Ralph Garney, James McGuire, unidentified, Henry McNulty, unidentified, Ralph Chase, unidentified, Charles Manning, unidentified, and ? Thompson.

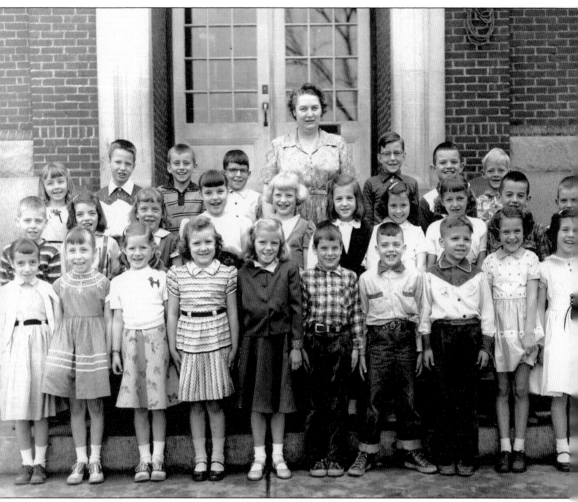

A Second-Grade Class, 1954–1955. Pictured, from left to right, are the following: (front row) Susan Aveni, Cathleen Morris, Catherine Boscia, Patty Pelchat, Linda Rockwell, Peter Turcotte, Russell Merrill, Michael Ignachuck, Ellen Caughey, and Louise Pratt; (middle row) Gregory Gurley, Sandra Fowler, Kathleen Bliss, Kathleen Leonard, Christiane Kelley, Micheleen Mahoney, Theresa Stitham, Joan Champlin, John Ferguson, and Stephen Trombley; (back row) Bonnie McGrath, Michael Young, David Richardson, Norman Ouellette, ? Phillips, Bruce Rouleau, Jack Bodwell, and Alann Courage.

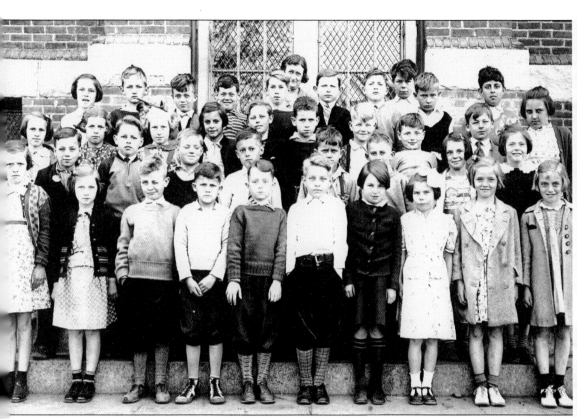

A THIRD-GRADE CLASS, 1938–1939. These students attended their classes at Garden Street School. From left to right are the following: (first row) Mary Smith, Nancy Fitch, Johnny Walker, ? Gillis, ? Dyer, Harold Rand, Betty Watson, Ada Mae Kimball, Barbara Deans, and Carol Tonella; (second row) Lionel Pelchat, Ernest McFane, Richard ?, Win Kitteredge, Carl Patten, Robert Hutchinson, Elizabeth Johnson, and Joyce Porter; (third row) Mary Ann Clark, Joanne Faustini, Joan Ruonola, Shirley Langille, Charles Ethridge, Lawrence Piper, James Philbrick, Edward Conley, Archie Carpentiere, and Marion Blanchard; (fourth row) Joyce Ordway, D. James Philbrick, Jimmie Cooney, Jimmie Villane, Lawrence Fournier, Russell Howland, James McEntee, Arthur Hendrickson, and Rosario Granata; (fifth row) Muriel B. Young and Herbert Leach.

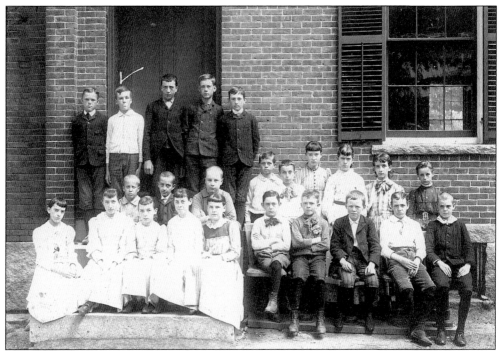

A Brick School Class. This picture was taken in 1891, and the class is from the Brick School on School Street.

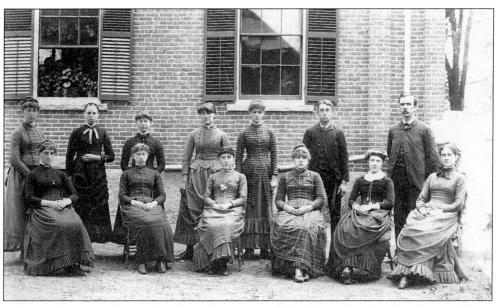

A Class Reunion. Pictured is the 25th reunion of the Class of 1887. The photograph was taken at the Brick School *c.* 1912.

THE OLD BRICK SCHOOL. This is the current Cabinet Press building across from the fire station. It was built in 1853 by the Milford School District. It was known as the "brick school" and was state of the art at the time it was built. At one time, this building housed school kids in all 12 grades. It operated as a school until the Garden Street School was opened in 1926. The Rotch family purchased the old brick school in 1945 and moved the Cabinet Press there in 1950 from its previous location at the beginning of Elm Street just east of the high school.

THE GARDEN STREET SCHOOL. Construction on this new school began in 1925, and it opened for its first full day of school on January 4, 1926. This new school would alleviate many of the overcrowding issues facing the town at that time. In June 2002, the last classes for Milford elementary students at Garden Street were held, as the school was being retired after 76 years of service.

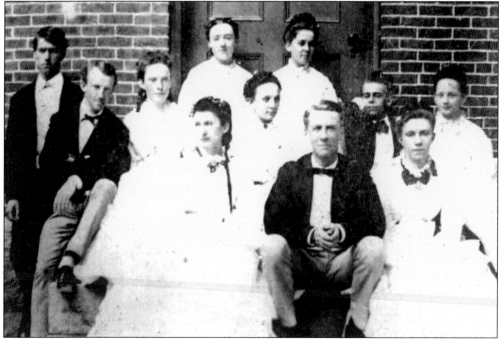

THE CLASS OF 1873. This photograph was taken at a time when there was only one high school teacher in town. These high school students attended the brick school on Middle Street, which is now the home of the Cabinet Press.

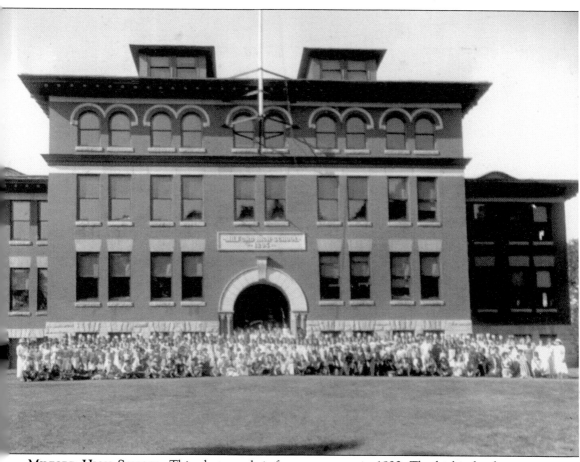

MILFORD HIGH SCHOOL. This photograph is from a pageant in 1923. The high school seen in the background was built in 1894, when the town celebrated its 100th anniversary. The building served as the high school until 1961, when the existing high school was built on West Street. As growth demanded, additions were made to the back of the school building over the years. A "mechanics arts" section was added in 1917. A gymnasium was added in 1939, and a four-room addition was made off the gymnasium in 1951. The school was refurbished and renamed the Bales Elementary School in 1969.

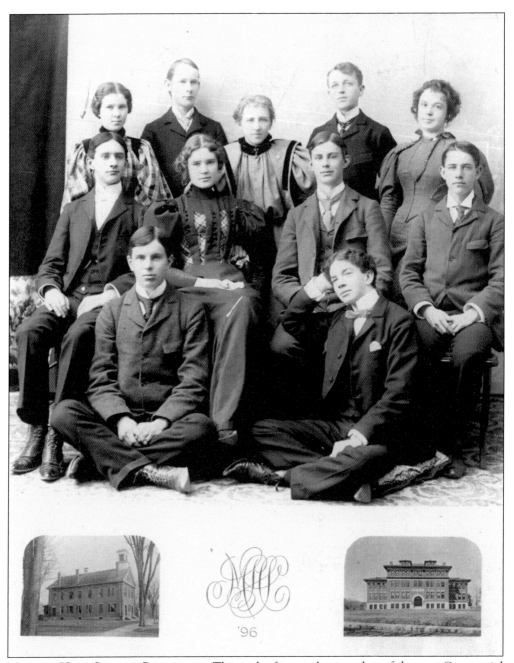

'96

MILFORD HIGH SCHOOL GRADUATES. This is the first graduating class of the new Centennial High School in 1896. These 11 students began high school in the old brick school (now the home of the Cabinet Press) and attended their final years at the new high school. From left to right are the following: (front row) Donald Tuttle and Charlie Philbrick; (middle row) Fred Winters, Ivah Kenny, Leonard Tuttle, and ? Webster; (back row) Alice Follett, Wallace Foster, Helen Amsden, Edmund Dearborn, and Bertha Stanyan.

Five

AROUND TOWN

THE RESIDENCE OF JOHN MCLANE. This house was located at the current location of Brooks Pharmacy on Grove Street just to the north of the post office. It was built in 1838 and had several owners up until 1962, when it was torn down to make room for a market. The most famous of residents was John McLane, who operated the McLane Manufacturing Company on Nashua Street. He also served as the governor of New Hampshire from 1905 to 1907.

THE STONE HOUSE. With Milford being known as the Granite Town of the Granite State, it would only seem fitting to have a building made from native granite. This stone house was built in 1818 by Benjamin Goodwin on Nashua Street. It was sold to Reed Dutton c. 1847 and remained in the Dutton family for more than 100 years. It has had several owners since the Duttons and has recently stirred up some controversy in town, as developers have been looking to develop the property. Thanks to concerned citizens, it appears that the stone house will be saved.

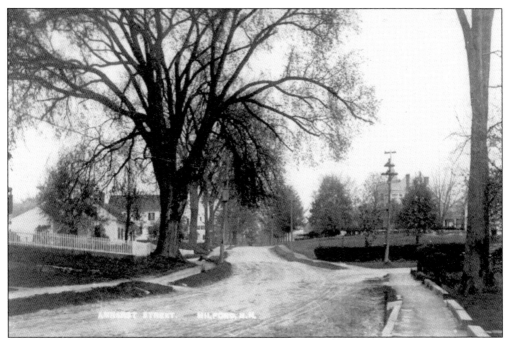

AMHERST STREET, LOOKING EAST. This undated photograph was taken from a postcard. It shows the junction of Amherst Street and Souhegan Street (right). With the exception of the empty lot on the corner and the lack of tar on the road, this scene does not look too much different today.

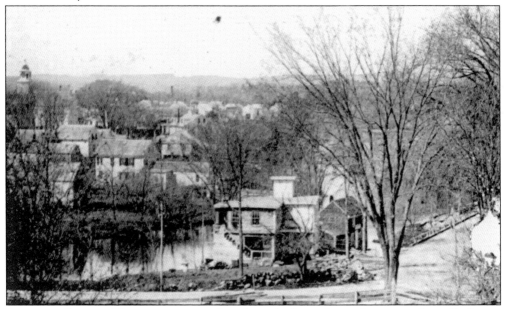

AMHERST STREET. This picture was taken from Amherst Street from just above Souhegan Street, looking toward town. The Knowlton family owned the building on the corner of Souhegan Street and Amherst Street, and they ran a boot shop at this location. It was torn down in 1957 to make room for a gas station. Today, the location is home to Dee's Glass across from St. Patrick's Church on Amherst Street.

NASHUA STREET PROPERTY. If this photograph were taken today, you would be looking at the backside of the Edgewood Plaza on Nashua Street. The stone house can be seen across the street. This property was purchased for the new French & Heald factory after a fire in 1912.

SQUIRE LIVERMORE'S OFFICE. This building sat on the lawn of the Congregational church and was built in 1834. It was directly across the street from the community house, which was the home of Solomon Livermore. After Livermore's retirement, Bainbridge Wadleigh and Robert Wallace used the building for a law office. In 1882, it became a candy store. In 1900, the building was moved just to the east of what is today Elisha's, a restaurant on Nashua Street, and is still incorporated in the house that stands there today.

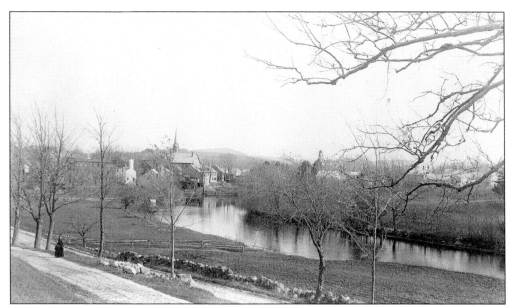

A SOUHEGAN RIVER SCENE. This photograph was taken at a time when there were very few trees between the river and Mont Vernon Street. The three buildings that stand out in the distance are the old fire station on the Oval, the Baptist church on South Street, and the Congregational church on Union Street. This picture must have been taken before 1894, as there is no sign of Centennial High School across the river.

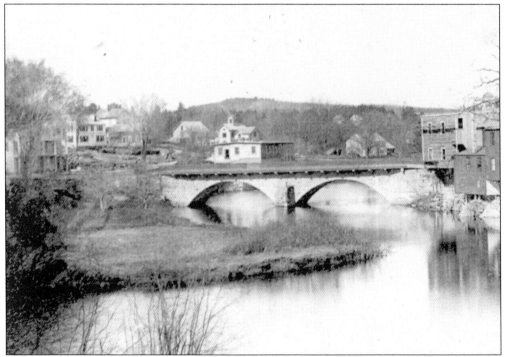

THE SOUHEGAN RIVER AND THE STONE BRIDGE. Taken from where Great Brook deposits into the Souhegan River, this photograph shows the stone bridge and, just beyond, the original Shepard sawmill. The land on the left side of the picture is today the home of Emerson Park.

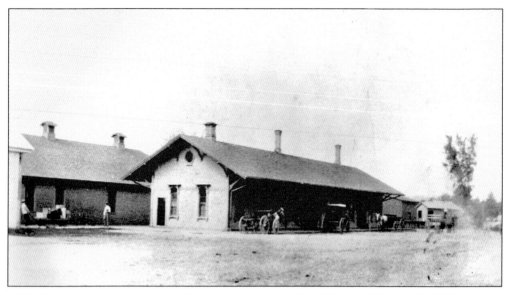

THE GARDEN STREET DEPOT. This undated photograph shows the Garden Street Depot, which served the Boston and Maine Railroad links between Nashua and Milford and between Milford and Wilton. It was built in the 1850s and still stands today. The line was also continued to Manchester in 1900, but with the automobile becoming the preferred means of transportation, the line was discontinued in 1923.

NASHUA STREET. This undated picture was taken along the sidewalk on Nashua Street between the entrance to High Street and Cumberland Farms. The McLane mill buildings, which eventually became the White Elephant Shop, can be seen at the far right.

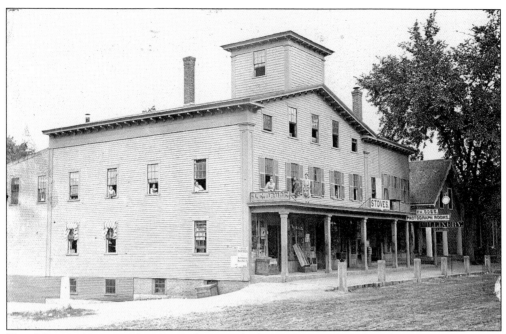

THE MELZAR BLOCK. This 1882 photograph shows the building then known as the Melzar House, on Nashua Street at the corner of Putnam Street. It was a boardinghouse for many of its years. The first floor housed the market of John E. Bruce. He had his market in the west space for 42 years.

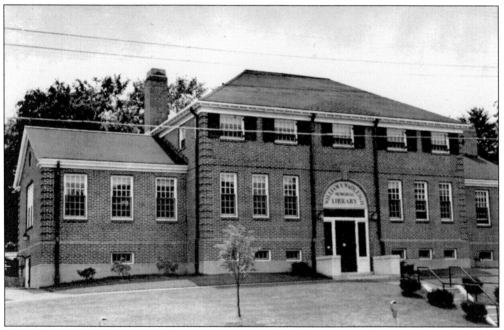

THE WILLIAM Y. WADLEIGH MEMORIAL LIBRARY. The library was built in 1950 on the former property of the Lull estate. This photograph shows the library at its original size. A wing was added to the east end of the building in 1986. Fannie L. Wadleigh contributed $100,000 to the town in 1932 to build a new library in her husband's name after her death.

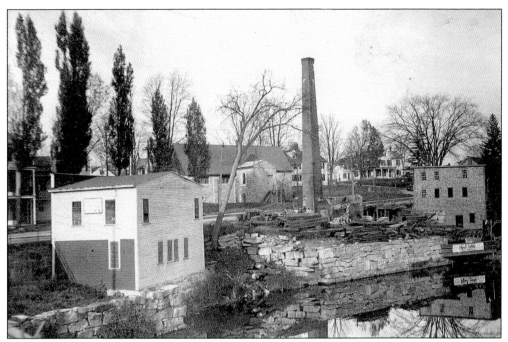

AMHERST STREET FROM THE STONE BRIDGE. This undated photograph shows the buildings that stood at one time along the south side of Amherst Street. The stone foundation and brick chimney are the original location of the original Shepard sawmill. In 1916, a crowd of people gathered to see a contractor demolish the 60-foot brick steam chimney. It was knocked to the street by taking out the lower bricks with sledgehammers.

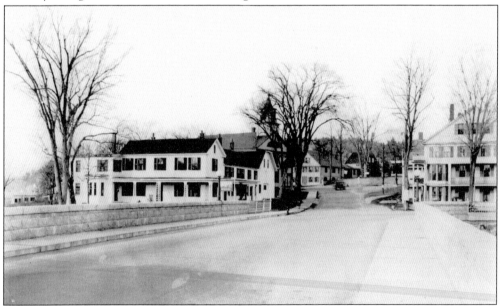

ACROSS THE STONE BRIDGE. Here is a view that has changed considerably over the years. This photograph was taken from the stone bridge just about in front of today's Milford Diner. On the left is the building that was torn down to make room for the U.S. post office. On the right is the Whittemore Block, which was torn down in 1950 to make room for a service station.

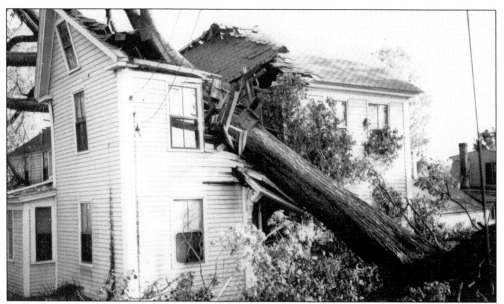

THE HURRICANE OF 1938. In a time when weather forecasting was not as accurate as it is today, Milford was taken by surprise on September 21, 1938, by a major hurricane. Sustained winds in Milford approached 100 miles per hour and caused major damage. Most of the town was without electricity for an entire week. A tree fell on this house on High Street; the house was later repaired and still stands today.

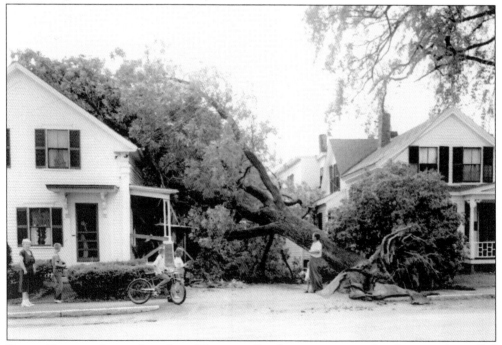

STORM DAMAGE. It must have been Hurricane Carol or a very severe thunderstorm that rolled through town in 1954 to cause damage to this degree. This photograph was taken on Union Street on July 31 of that year. Both of these houses still stand today on the east side of Union Street just after the railroad tracks.

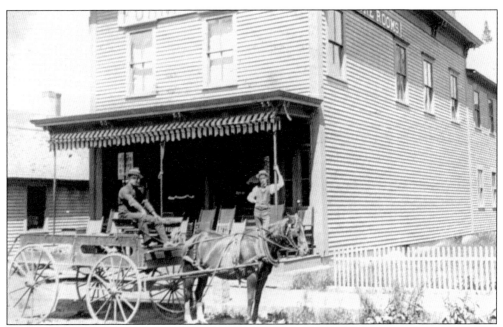

EMERSON FURNITURE. This building housed the furniture business of Sumner B. Emerson. The business was handed down to his son Charles S. Emerson in 1887. This building was located on South Street just south of where Bravo Pizza is today. It was eventually moved to the corner of Union Street and Union Square. Emerson built the existing brick building on South Street in 1895 to replace this building. Emerson did a lot for the town of Milford and was very active in town affairs. He died on October 1, 1952, at the age of 86.

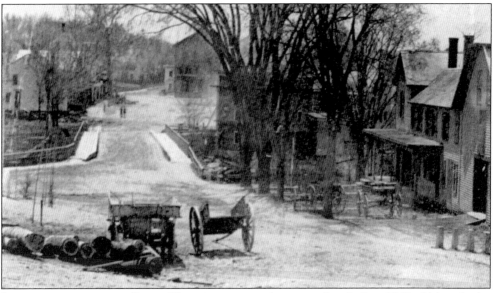

LOOKING TOWARD THE OVAL. This picture was taken sometime before 1869. Although the quality of the picture is not very good, it is easy to see the absence of the town hall and Eagle Hall where they are today. The picture was taken from the corner of Mont Vernon Street in front of today's Brooks. If you look behind the trees, you can see the tower of Eagle Hall sitting in its previous location.

A TOWN HALL AERIAL PHOTOGRAPH. This is another picture taken from the steeple of the old Baptist church on South Street. The town hall is seen here before the library annex was built in 1892. In the background is the intersection of Amherst Street and Summer Street in a time when there were far fewer houses.

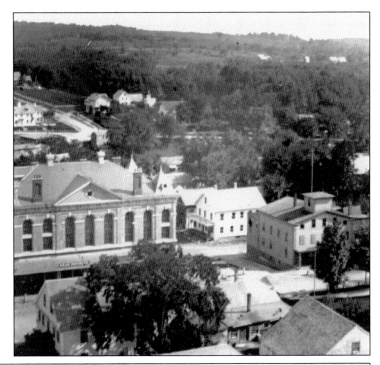

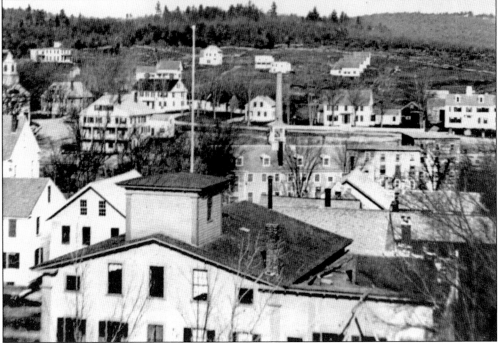

THE MILFORD HIGHLANDS. The area that now comprises Highland Avenue, Myrtle Street, and points north was at one time called the Milford Highlands. In this picture, taken from the site of today's library (then the Lull estate), the Melzar Block is shown across the street, and at the top of the photograph is the Highlands area and the few houses that were then on Myrtle Street and Highland Avenue.

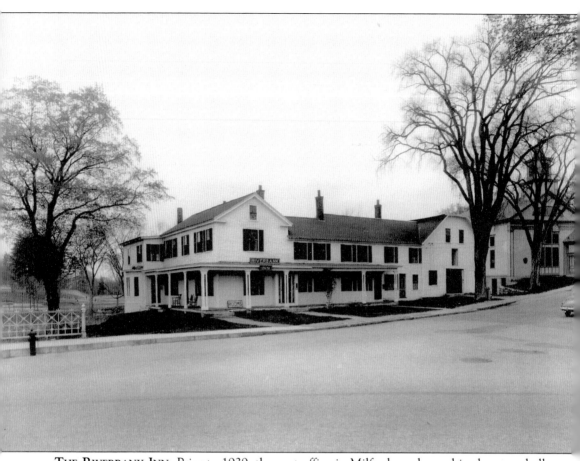

THE RIVERBANK INN. Prior to 1939, the post office in Milford was housed in the town hall. Due to growth and space requirements, the government started looking for a location to build a new post office in 1933. This house overlooking the river appears to have been built by Zebediah Holt sometime after 1818. The property had many owners over the years, including Ebenezer Pearsons Jr., Thomas Melendy, William and Henry Gilson, Iona Jacobs, and Margaret Fitzgerald and Nellie Snow. It was this last pair who sold the house and property to the U.S. Post Office Department in 1938. The house was then torn down, and the current post office was built in this spot. The post office building was remodeled in 2001.

NASHUA STREET JUST OUTSIDE UNION SQUARE. The first building on the left in this picture stood at what is today the entrance to Putnam Street just east of the town hall. Putnam Street from Nashua Street to Middle Street is no longer a road that can be traveled by automobile and is gated off. The origin or history of the subject building is not known.

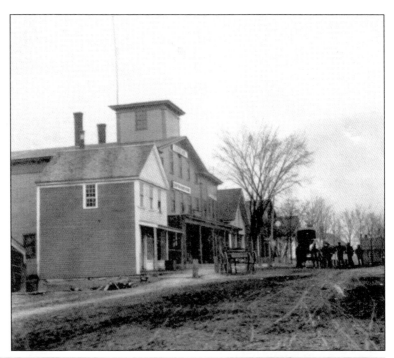

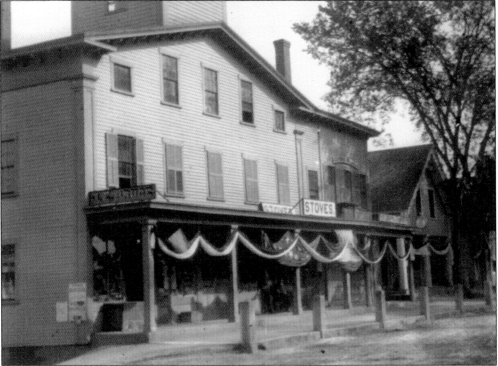

THE EXCHANGE BUILDING. This building was also known as the Melzar Block, named after one-time owner Ezra Melzar. The building is located on the corner of Putnam and Nashua Streets. The establishment in the east store space, advertising "stoves," was most likely the plumbing shop of J.F. Boynton.

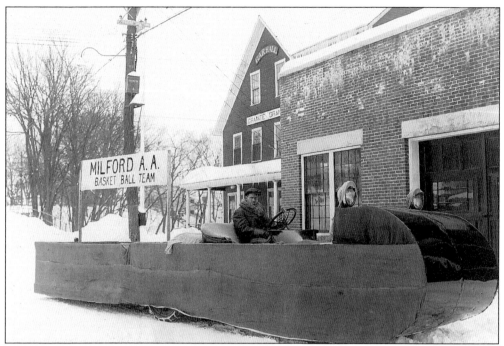

AN ANTIQUE PARADE FLOAT. An unidentified man sits in what appears to be an old parade float made for the Milford Athletic Association's basketball team. This picture was taken prior to 1927 directly across from where Cottage Street meets Elm Street. The Granite Grange hall in the background was destroyed by fire in December 1926.

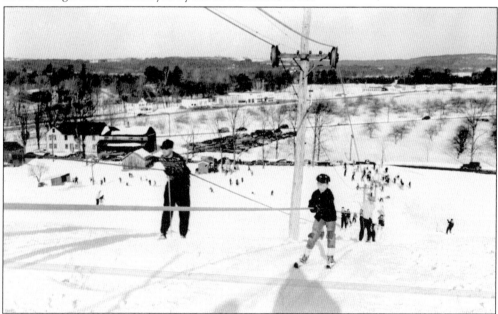

TWIN TOWS. This picture was taken from the top of Twin Tows on March 2, 1952. Today, Twin Tows is just a memory from the past. It was located on the large hill (Dram Cup Hill) that overlooks the rear side of Market Basket in west Milford. Skiing with a modern rope tow was started there in 1946 by Mr. and Mrs. Grant McKenzie.

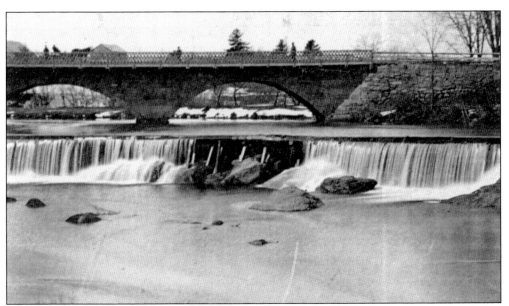

THE MORSE & KALEY DAM. This dam, located just to the east of the double arch stone bridge coming out of Union Square, helped power several industries. It was the power plant for the Morse & Kaley Manufacturing Company, which operated the mill building on Bridge Street, and it also powered the Shepard sawmill on the other side of the river.

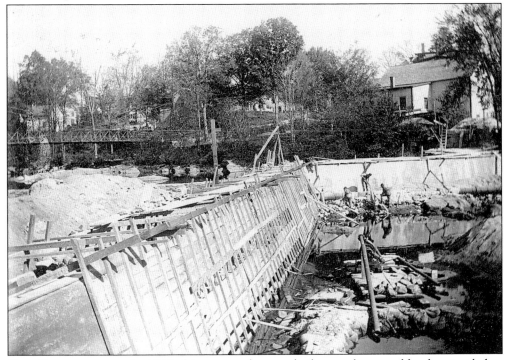

DAM CONSTRUCTION. In 1909, this cement dam was built to replace an older dam just below the swing bridge. At the time of this construction, the Milford Light and Power Company owned the water rights, and the dam was used to generate electricity. Electric lights were first seen in Milford in 1889.

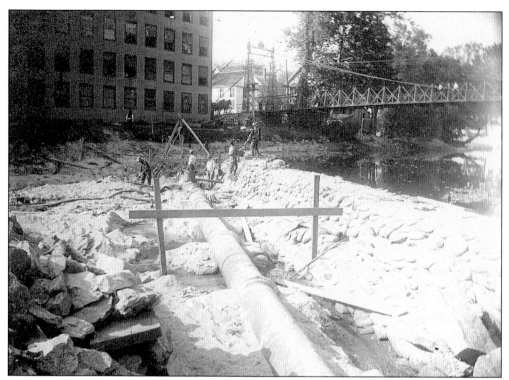

A SEWER LINE. In this photograph taken prior to 1912, the swing bridge and the French & Heald Company can be seen. Workers have excavated below the swing bridge to put a sewer line in place.

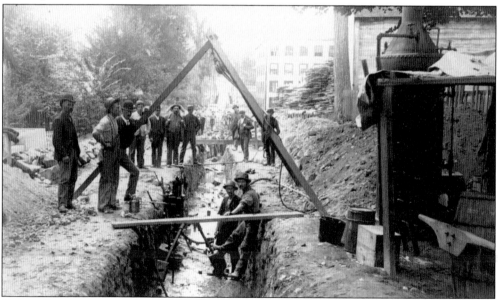

SEWER CONSTRUCTION. This picture probably dates from *c.* 1889 or 1890, when Milford's first sewer system was installed. It shows workers on Bridge Street (then Maple Street) with a trench for the sewer pipes. The swing bridge, which was almost brand new at the time, can be seen at the end of the road.

PROSPECT HILL, LOOKING NORTH. This photograph was taken from Prospect Hill. The building on the left is on Clinton Street and was known as the Melzar Block. It was later known as the Finn Block. At one time, part of it was used as a train depot and sat across the street at the corner of Clinton and South Streets. The building is still used today as an apartment building. The road to the right of the building is Franklin Street.

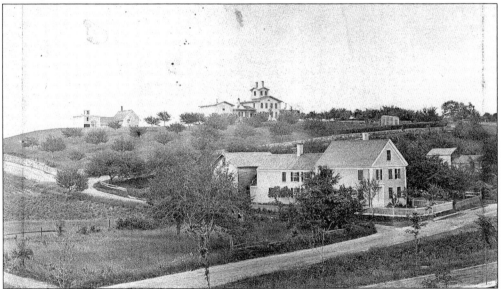

PROSPECT HILL. This undated photograph shows the entrance to Prospect Street off South Street at a time when there were far fewer trees than there are today. The top of Prospect Hill must have offered a great view at this time. The hill has been known over the years as Gilson Hill and Prospect Hill.

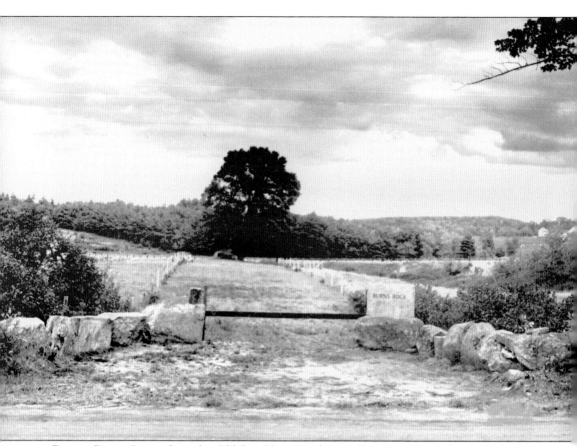

BURNS ROCK. Located on the Old Brookline Road just off Armory Road, Burns Rock is now covered in a canopy of trees. In August 1923, a bronze tablet was placed in the boulder in memory of John Burns. John Burns was one of the original settlers in what is today the area of Milford. He was born in 1700 and came to America from northern Ireland in 1736. He bought 100 acres of land around the area of Burns Rock and brought his family here in 1746 from Nottingham West (Hudson). He was a prominent citizen of the old town of Monson and died in 1782, before the incorporation of Milford. There are still descendants of John Burns in town today.

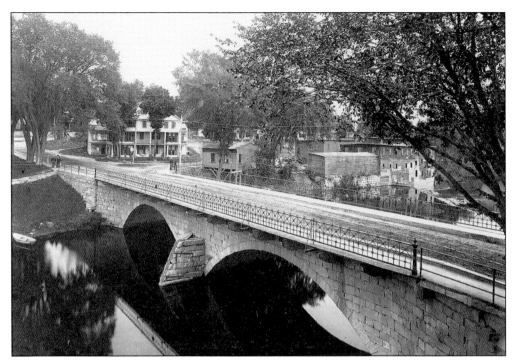

THE DOUBLE ARCH STONE BRIDGE. There has been a bridge at this location on the north side of Union Square since before 1758. The first bridge was a private footbridge built by John Shepard. There were bridges built in 1783, 1794, 1802, and 1808. These bridges were all made of wood and did not last long. The existing bridge (shown) was built in the mid-1800s and was widened to its current size in 1931.

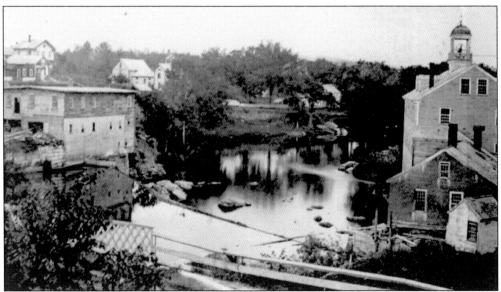

THE SOUHEGAN RIVER, LOOKING EAST. To the left side of this picture is the site of the original Shepard mill, built in 1741. When the mill was constructed, this area was still a part of the Southwest Parish of Amherst. To the right is the Morse & Kaley linen mill. At the bottom of the picture is a piece of the bridge crossing the river prior to the current stone bridge.

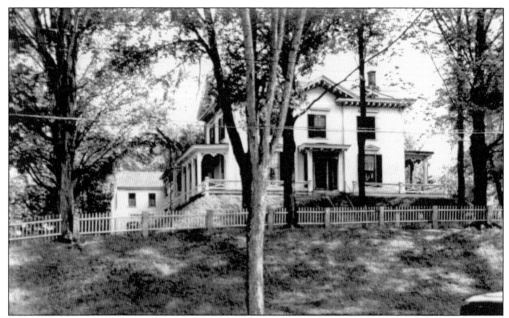

LULLWOOD. This large two-family house stood where the William Y. Wadleigh Memorial Library stands today. It is presumed that Hiram Daniels built the house prior to 1855. In later years, Oliver and Mary Lull resided in the west half of the building. A beautiful fountain on the grounds of this property was preserved and can be seen today at the west end of the library.

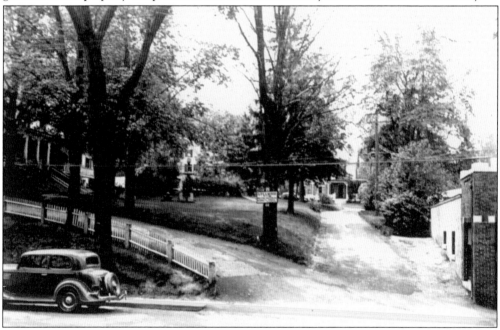

LULLWOOD. Lt. Col. Oliver Lull was killed during the Civil War. Mary, his widow, went on to become a doctor and practiced in town until 1900. In 1910, Mary Lull left her half of the property to the town. The building was eventually torn down. In combination with funds left by Fannie L. Wadleigh in memory of her husband, the present-day library was built on this site just slightly nearer the road.

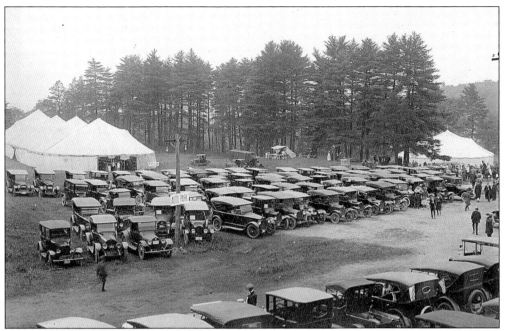

ENDICOTT PARK. The field occupied by these tents and cars is now the location of Jacques Memorial School. Endicott Park was the town's main recreation spot from 1885 until the opening of Keyes Field in the early 1960s. Baseball games, fairs, ice-skating, concerts, and all kinds of activities were held there. What is left of Endicott Park today is the playground used by schoolchildren behind Bales Elementary and Jacques Memorial Schools.

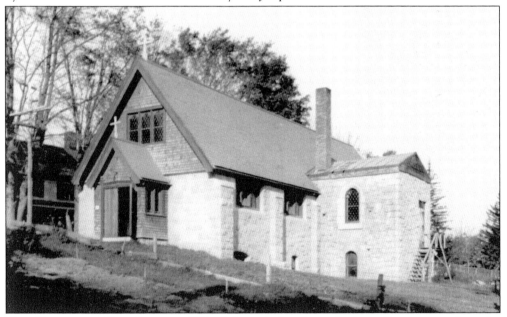

THE CHURCH OF OUR SAVIOUR. This Episcopal church on Amherst Street across from the original Shepard mill site was built in 1901. In 1957, a new section was added to the east end of the original building. In 1985, yet another addition was built to the west end of the original building.

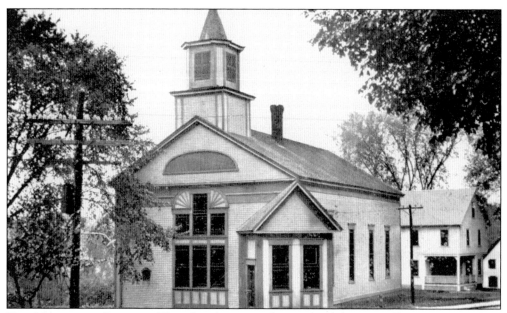

THE METHODIST CHURCH. This church just to the north of the post office was originally a Baptist church and was built in 1812. The Methodists purchased it in 1877 for $1,500 and are still in possession of it today. Many changes have been made to the building over the years, including a change in color in 1951 from light brown to its current white.

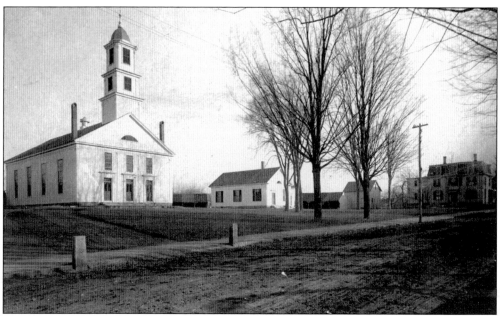

THE CONGREGATIONAL CHURCH. The Congregational church and its parish house on Union Street are pictured here. The church edifice was built in 1834 and has seen many changes over the years. Major repairs were made to the building and grounds in 1900 and 1913. A fire destroyed the interior of the church in 1947, but it was repaired and remodeled. The steeple needed extensive repairs in 1957 after being struck by lightning.

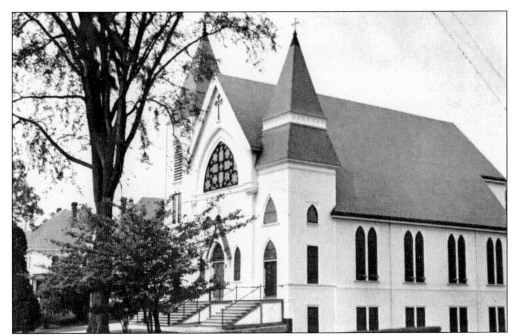

ST. PATRICK'S CHURCH. Milford's original Catholic church was built on lower Souhegan Street in 1859, and the building burned down in 1902. Due to an increase in the Catholic population, a much larger, modern church was started in 1890 and is today St. Patrick's Church on Amherst Street. From 1890 until 1915, services were held in the basement until the building could be completed. Due to a lack of funds, the church building as we know it today was not ready and dedicated until 1916.

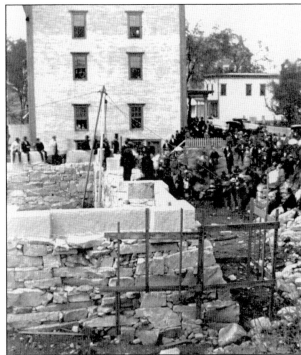

THE CHURCH FOUNDATION. This is a picture of the newly built foundation for the Baptist church on South Street. The church was built in 1874 and was razed in 1972. The property is now the location of the Bank of New Hampshire. The building to the north is the Pointer Block, which was torn down in 1944.

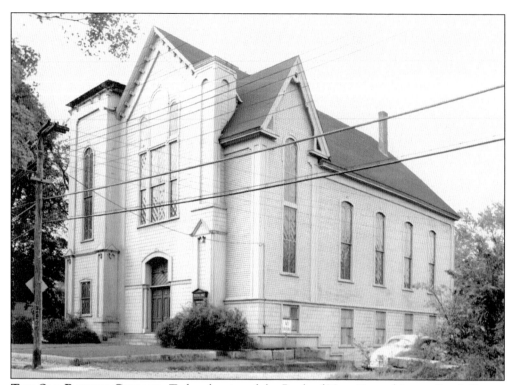

THE OLD BAPTIST CHURCH. Today the site of the Bank of New Hampshire on South Street, this location served as the home for the First Baptist Church of Milford for 98 years. This picture shows the church at a time when it did not have a spire. The church had several different spires over the years. The first one was only 30 feet tall. One of the spires measured 150 feet from the ground and was the vantage point for many of the early aerial photographs in town.

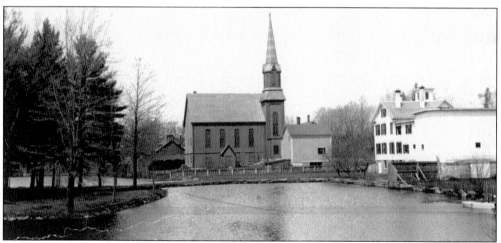

BICENTENNIAL PARK. This picture was taken from the land that is Bicentennial Park today. The Baptist church can be seen on the other side of the pond. The church was razed in 1972. The Milford Conservation Commission obtained this property on South Street bordering Railroad Pond in 1973. The park was dedicated in 1975 as part of Milford's celebration of the national bicentennial.

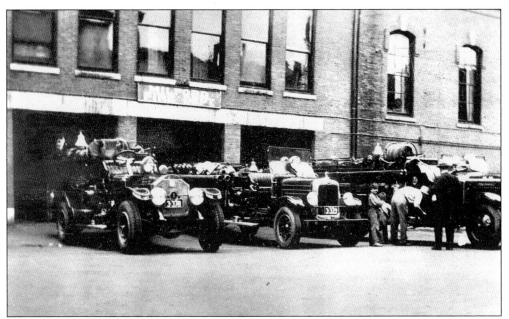

THE MILFORD FIRE DEPARTMENT. What today are the service bays for the Milford Ambulance Service was at one time home to the Milford Fire Department. The department outgrew its former home on the west side of Union Square in 1892 and moved into the brand-new library annex of the town hall in 1892, calling it home for 83 years.

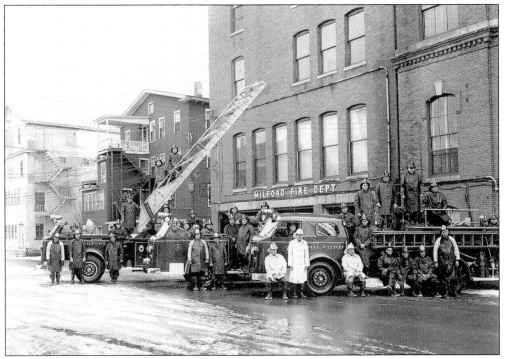

THE FIRE DEPARTMENT. This undated photograph shows the fire department before it moved to its new home on School Street in the mid-1970s. The firemen proudly display their fire trucks, including a ladder truck.

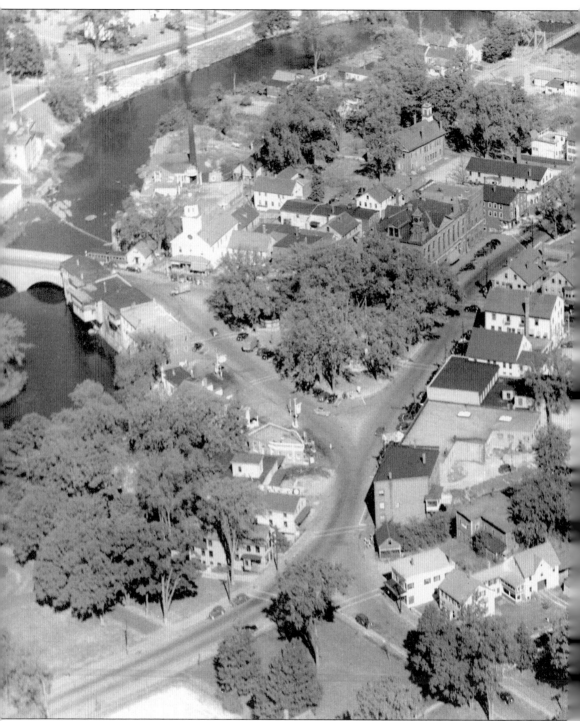

DOWNTOWN MILFORD. This aerial photograph dates from *c.* 1940. The west side of South Street has seen significant changes since then. On South Street, the Pointer Block, which occupied the site that is now the north parking lot of the Bank of New Hampshire, was torn down in 1944. The Baptist church was torn down in 1972 and was where the Bank of New

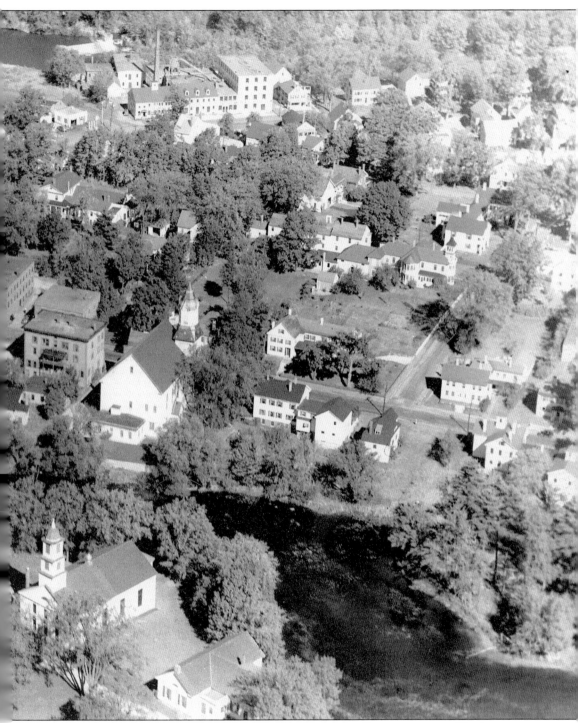

Hampshire is today. To the north of the Pointer Block was a small service station. The location where this service station was has been a parking lot behind the Dyer Block since 1949. The home to the south of the Baptist church was torn down in the 1980s and is now another parking lot for the Bank of New Hampshire.

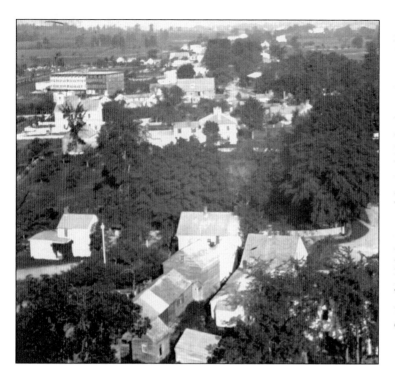

AN EARLY AERIAL PHOTOGRAPH. Before the invention of the airplane, aerial views like this were typically taken from the tallest of church steeples. This photograph was taken from the steeple of the Baptist church on South Street. The middle house in the foreground is the Carey House, which is now the home of the Milford Historical Society. The large building in the background is the old tannery.

ANOTHER EARLY AERIAL VIEW. This is another photograph taken from the steeple of the old Baptist church on South Street. In the foreground is the Congregational church and its parish house. In the background, the buildings along Garden Street can be seen, including the train depot.

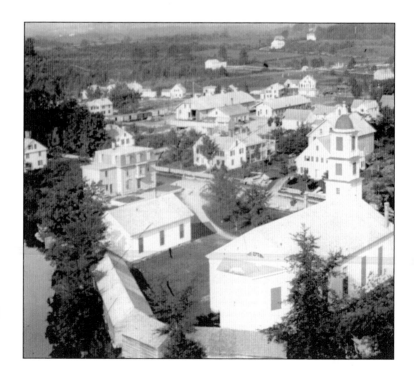

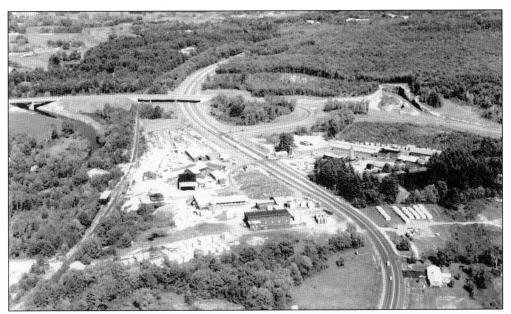

AN EAST MILFORD AERIAL VIEW. Flying over this spot today, you would see the Lorden Plaza, where the Shaws supermarket is, and the abandoned mill buildings across the street. When this picture was taken, Lorden Lumber was still in business, and the closest supermarket was the A & P in the Edgewood Plaza, where today there is a fitness center and a restaurant.

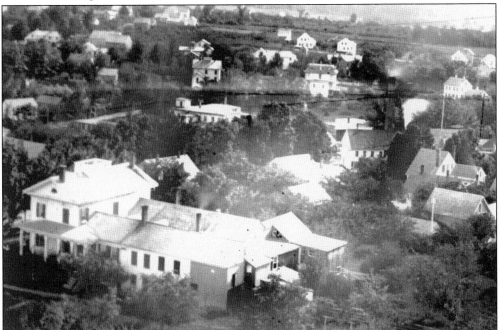

AN AERIAL VIEW OF THE LULL ESTATE. Shown is yet another view from the steeple of the old Baptist church on South Street. The large complex in the foreground is the Lull estate. It is located where today's William Y. Wadleigh Memorial Library is on Nashua Street. It was the residence of Col. Oliver W. Lull, a Milford attorney. He died during the Civil War from a wound he received in the battle of Fort Hudson.

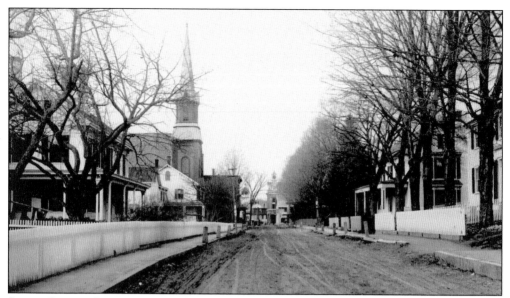

SOUTH STREET, LOOKING NORTH. This view was taken at a time when the streets were dirt and sidewalks around town were lined with granite hitching posts. The east side of South Street does not look all that different today. The west side, on the other hand, has changed drastically.

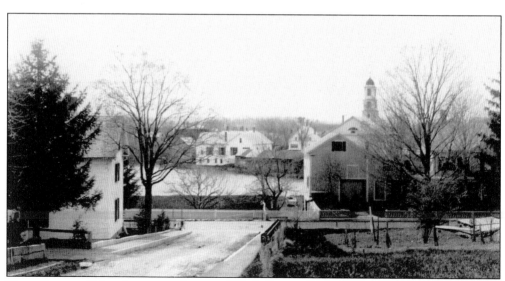

HIGH STREET. Taken from near the top of High Street, this view shows the junction of High and South Streets, Railroad Pond, and the Congregational church's parish house on the other side of the pond. The photograph is undated.

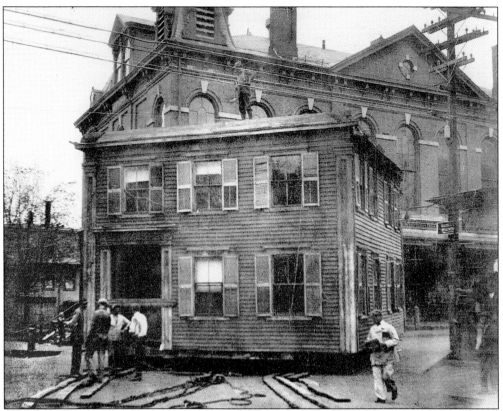

MOVING A BUILDING. Many years ago, it was a common practice to move buildings instead of building new ones. All of the buildings on the east side of Union Square, as well as the buildings on Middle Street, were all moved in 1869 to make room for the new town hall. This picture shows a house on the move in 1927.

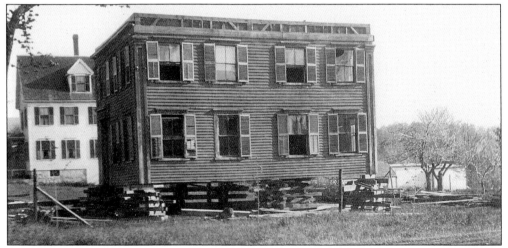

AN OLD HOME IN A NEW SPOT. The previous picture shows a house that once stood on the corner of School and Nashua Streets (now a parking lot) being moved. This picture shows the house at its final destination. The house is still standing today just shy of a half mile from the Oval at 211 South Street.

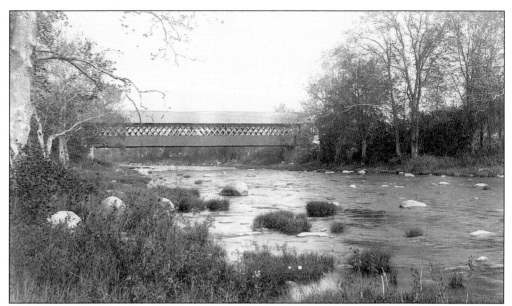

THE COVERED BRIDGE AT JONES'S CROSSING. This covered bridge was built in 1872 in the vicinity of the now closed green iron bridge in west Milford. This was the first bridge in the Jones's Crossing area. Before it was built, the river was crossed at a shallow ford in the area. The bridge burned and was destroyed on February 26, 1911.

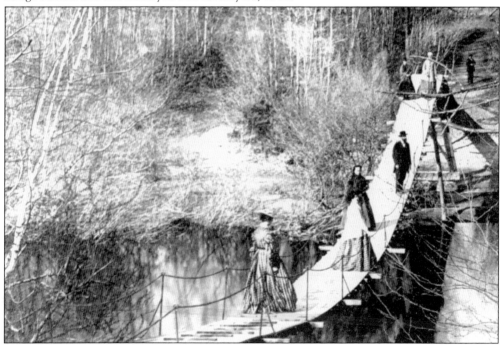

A WOODEN FOOTBRIDGE. This antique bridge was farther east along the river than today's swing bridge. It existed in the 1860s and was located across the street from the entrance to Clinton Street. The bridge was primarily used for the workers of the Souhegan Cotton Mill on Souhegan Street to get to the other side of the river. It was deemed unsafe and was torn down in 1870.

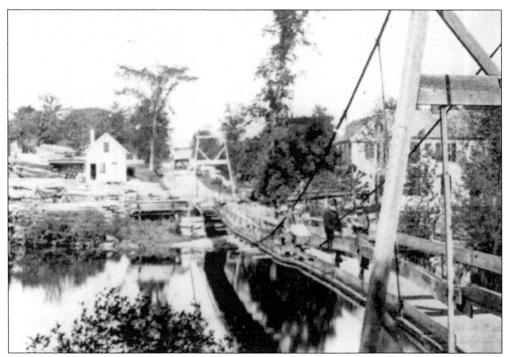

A WOODEN SWING BRIDGE. Before the existing iron swing bridge was built to connect Souhegan Street and Bridge Street (formerly Maple Street) in 1889, there were two bridges in this location. The first was built in 1850 and was washed away in a freshet in 1869. It was replaced by a bridge that was used for 20 years before the existing bridge was constructed.

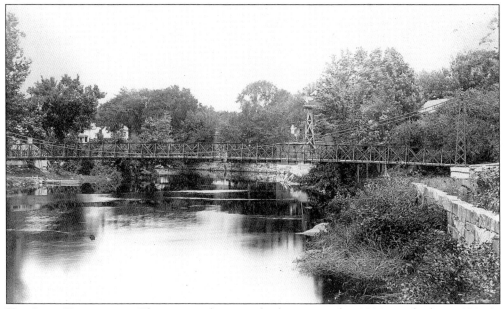

THE IRON FOOTBRIDGE. The current-day swing bridge, pictured c. 1891, was built in 1889. At the time, it cost the town $3,500 for the new construction. The two previous bridges that were in this location were made from wood and swayed significantly compared to this iron bridge. The footbridge connects Bridge Street and Souhegan Street.

NASHUA STREET. You would be risking your life to stand in the middle of Nashua Street today to get this picture. The photograph was taken just to the east of the entrance to High Street when traffic was not so great an issue as it is now. Many of these houses still stand today. Farther up the road, you can see the McLane plant.

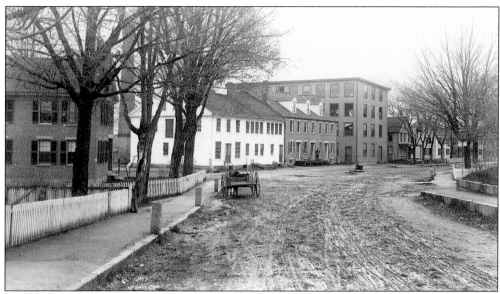

NASHUA STREET, LOOKING EAST. If this picture were taken today, the brick house on the left would be the location of a service station, and the complex of buildings in the middle would be the location of the Cumberland Farms building. The road was dirt at the time of this photograph and was traveled by horse and carriage. Notice the granite hitching posts along the curbside.

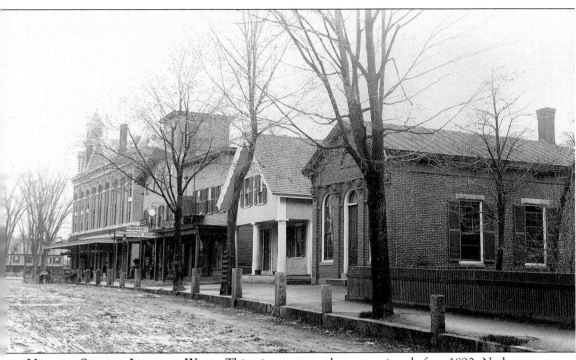

NASHUA STREET, LOOKING WEST. This picture was taken sometime before 1890. Nashua Street was still dirt, and the sidewalks were lined with granite hitching posts. The first building on the right was the original Souhegan National Bank and remained the size shown until 1904, when the bank building was enlarged. The second building was constructed in 1849 by Hezekiah Hamblett and served as his home. In 1890, Hamblett sold his property to George Avery. Avery had the house moved to Crosby Street and built the block that stands there today. The town hall, the Union Hotel, and the elm trees that once graced the Oval can be seen in the distance.

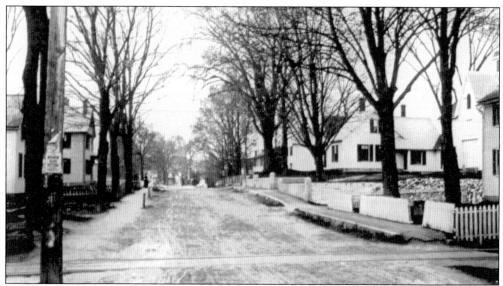

UNION STREET. The Milford Historical Society's collection of pictures contains very few pictures of Union Street. This image was taken from a turn-of-the-century glass slide. The view looks to the south toward Lincoln Street on the east and George Street, farther down on the west. The railroad crossing can be seen at the bottom of the picture.

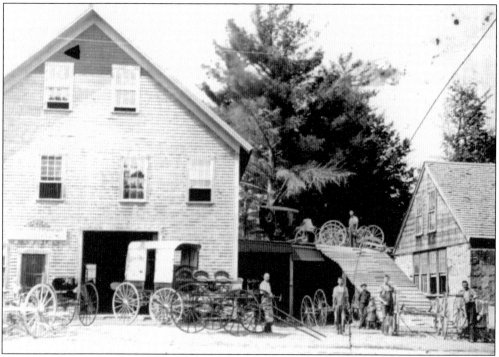

THE W.L. LOVEJOY CARRIAGE SHOP. The building on the left was at one time the paint shop of M.F. Crosby, Milford's armory, and the Granite Grange. When this undated picture was taken, it was the W.L. Lovejoy Carriage Shop, which performed carriage trimming and harness making, according to the sign. This building burned down in 1926 and was very close to the present-day entrance to Keyes Field.

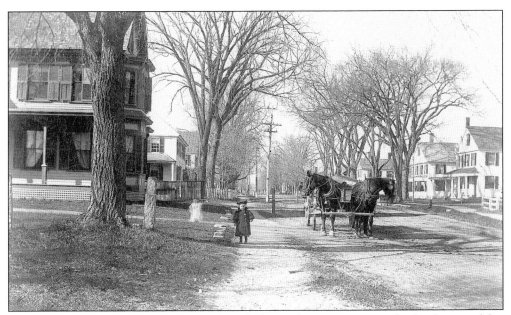

ELM STREET. An unidentified young lady and a horse-drawn carriage are the focal point of this undated picture. The photograph was taken across the street from the present-day entrance to Keyes Field, looking west. This view also highlights a once dominant feature of many of Milford's streets, giant elm trees.

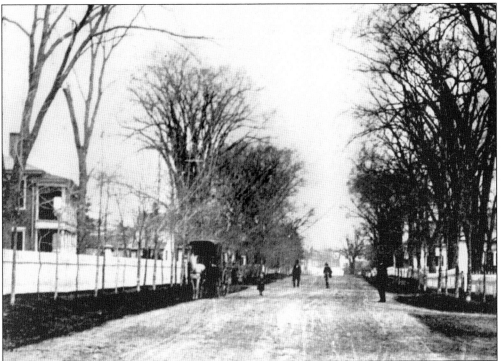

ELM STREET, LOOKING EAST. This picture was taken in the 1800s in the vicinity of the entry to West Street. This is the view toward the Oval. The Humphrey Moore house (left) still stands today. Rev. Humphrey Moore, who was Milford's first settled pastor, built the house in 1820.

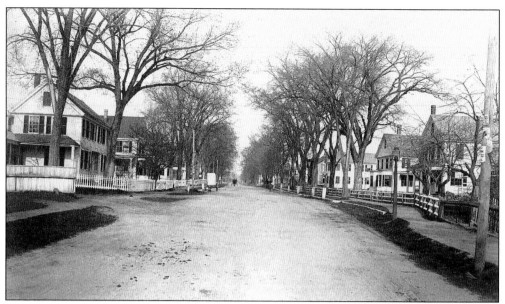

ELM STREET, LOOKING WEST. Here is another photograph taken in the vicinity of today's entrance to Keyes Field. It is obvious in this picture why the road once called the Wilton Road was given the name Elm Street. The prominent elms that lined the street were all claimed by Dutch elm disease. The disease was first discovered in the United States in 1930 and has destroyed more than half of the elm trees in the northern United States.

GOLF IN MILFORD. This photograph was taken on Mont Vernon Street just beyond the Colonel Shepard House on the other side of the road. Shown are a tennis court and the clubhouse for a golf course that ran along the river. The course was built in 1902, and the clubhouse was built in 1906. The course was closed before 1910, and the clubhouse was destroyed after the floods of 1936.

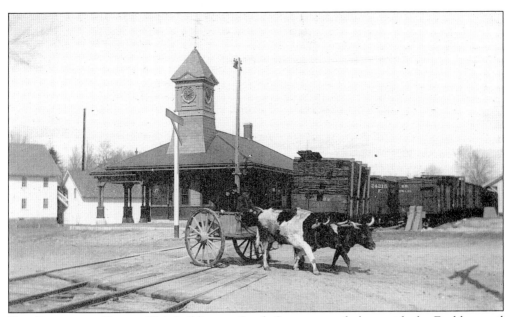

THE FITCHBURG DEPOT. This building on South Street opened along with the Fitchburg rail line in 1894. The line was critical to the granite quarries in the south end of town, as spurs were extended to them for removing the granite by rail. The Milford section of the old Fitchburg line is now the Granite Town Rail Trail, recently opened by the Milford Conservation Commission.

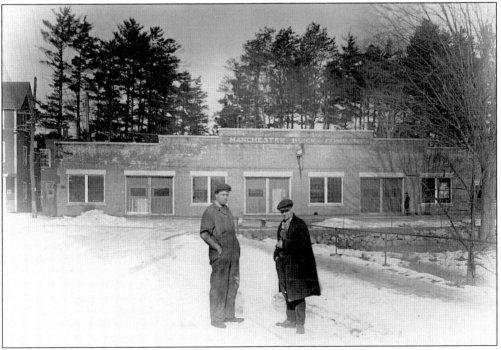

THE MANCHESTER BUICK COMPANY. These two men standing on Cottage Street in 1923 or 1924 are unidentified. The building in the background, the Manchester Buick Company, was owned by Walter Billings. This site later became the Fletcher Paint Works. The building was recently torn down as part of the EPA superfund cleanup.

A TRAIN-TRUCK COLLISION. This *c.* 1925 photograph, looking west, was taken at Richardson's crossing. This rail crossing is today on Old Wilton Road. According to reports, the damaged truck beside the tracks is a logging truck that was hit by the train.

A TRAIN-CAR COLLISION. This picture comes from a day or two after the previous picture in 1925. The view of Richardson's crossing looks east toward Milford. While people were gathered to view the accident scene from the previous picture, the train collided with this vehicle as well.